NORFOLK PLACES
BEHIND THE FACES

John Ling

AMBERLEY

First published 2022

Amberley Publishing
The Hill, Stroud
Gloucestershire, GL5 4EP

www.amberley-books.com

Copyright © John Ling, 2022

The right of John Ling to be identified as the Author
of this work has been asserted in accordance with
the Copyrights, Designs and Patents Act 1988.

ISBN 978 1 3981 1196 7 (print)
ISBN 978 1 3981 1197 4 (ebook)

British Library Cataloguing in Publication Data.
A catalogue record for this book is available from the
British Library.

Typesetting by SJmagic DESIGN SERVICES, India.
Printed in Great Britain.

Contents

Introduction

Norfolk Places Behind the Faces takes a look at locations linked with some of the county's best-known historical figures such as Lord Nelson, Nurse Edith Cavell, Anna Sewell, Elizabeth Fry, Howard Carter and many more. Most were born and raised in Norfolk but one unexpected temporary resident was the legendary Native American Pocahontas. The book also explores places connected with conflicts and uprisings including Boudicca's battles with the Romans, Kett's Rebellion and the Peasants' Revolt.

Norfolk has many links with royalty, from the aforementioned Iceni queen to the modern royal family. The present Queen famously owns Sandringham House in Northwest Norfolk and the late Diana, Princess of Wales, was born on the Sandringham estate. The Duke and Duchess of Cambridge currently reside at Anmer Hall near Sandringham. Norfolk has also played an important part in the lives of other royals including King John, Henry VIII and, of course, his doomed second wife, Anne Boleyn. The county also has connections with the last Maharajah, Duleep Singh, and his family.

In addition, the book looks at local places that inspired or featured in famous works of literature including *Black Beauty, David Copperfield, Robinson Crusoe* and two of the Sherlock Holmes stories, plus some of many Norfolk locations used in films and television programmes. It also explores the county's connections with some of the best-known pop and rock music acts and the places where they played. The Beatles were briefly the backing band for a Norwich-born singer, and they also recorded a song inspired by a circus performance staged by another of the city's sons. The group performed in Norfolk, as did David Bowie who famously name-checked the Norfolk Broads in one of his best-known songs. Several contemporary figures from the worlds of cinema, television and music were either born in the county or have made it their home.

This book was largely written during the Covid-19 lockdowns when virtually all visitor attractions were closed. Almost all have now reopened but it is advisable to check opening times before travelling.

1. Norfolk's Historical Characters

Lord Nelson

The road signs that greet visitors to Norfolk proudly proclaim: 'Norfolk: Nelson's County'. Such is his status as the county's most famous son that almost every town, village and public house seems to claim a connection with him.

Horatio Nelson came into the world without fanfare on 29 September 1758. The son of the local vicar, Edmund Nelson, he was almost certainly born at the old rectory in Burnham Thorpe. A memorial bust was installed in All Saints Church to commemorate the centenary of his death in 1905. One of eleven children, he was a sickly child who continued to suffer health problems for much of his life. He never lost his Norfolk accent and famously declared: 'I am myself a Norfolk man and glory in being so.' He was attracted to water from an early age and was familiar with Burnham Overy Staithe, Wells and other places along the North Norfolk coast.

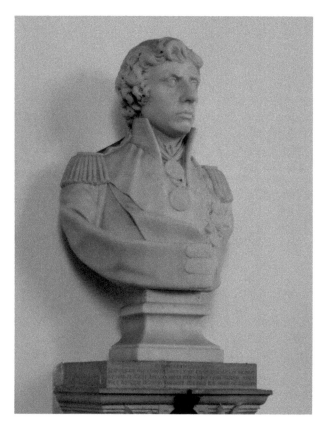

Bust of Lord Nelson, All Saints Church, Burnham Thorpe.

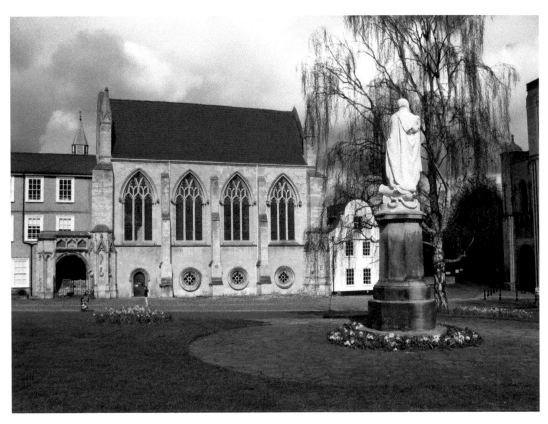

Nelson's statue facing the chapel of his old school in Norwich. (Courtesy of Norwich Cathedral)

Horatio and his brother William briefly attended Norwich Grammar School in 1767 but left after the untimely death of their mother at the age of forty-two later that year. They were then sent to Paston School in North Walsham. A statue of Lord Nelson by sculptor Thomas Milne was erected facing his old school in Norwich Cathedral Upper Close in April 1856.

Young Horatio joined the Navy at the tender age of twelve and in early 1771 became a midshipman on HMS *Raisonable*, a sixty-four-gun vessel captained by his uncle, Maurice Suckling. So began a career which would last until Nelson's death in battle over thirty-four years later. He held a dinner for villagers at the Plough Inn, Burnham Thorpe, before leaving on a voyage in January 1793. Built as an alehouse in 1637, this was a favourite drinking place of his and still exists. It is said to be the first public house in England to change its name to the Lord Nelson in 1798. Another pub, the Wrestlers Inn, Great Yarmouth, was the scene of a triumphant return to the county in 1800 following his victory at the Battle of the Nile. News of the famous visitor's arrival brought much of the town's populace out on the streets and he received a hero's welcome. A plaque on the front of the property – which was rebuilt following bomb damage in the Second World War but is no longer a public house – records that Nelson was made a freeman of the borough of Great Yarmouth there on 6 November 1800. By this time he had been blinded in one eye

at the siege of Calvi in Corsica and had most of his right arm amputated following a failed attack on Santa Cruz, Tenerife, on 24 July 1797.

Nelson married a young widow named Frances Nisbet on the island of Nevis in March 1787 but the couple became formally separated after his mistress, Lady Emma Hamilton, gave birth to their daughter Horatia on or around 29 January 1801. Following the Battle of Copenhagen in 1801, Nelson visited the Naval Hospital and Barracks in Great Yarmouth and was said to have spoken to all of the wounded servicemen. The building was on St Nicholas Road where a supermarket and warehouse now stand and a blue plaque records the visit. Following his outspoken criticism of the hospital, a large new one (now converted to residential use) was built at South Denes on the seafront in 1809–11 but he did not live to see it.

Nelson died at the age of forty-seven aboard *Victory* at the Battle of Trafalgar on 21 October 1805. Against his wishes he was buried at St Paul's Cathedral on 9 January 1806, instead of beside his parents at Burnham Thorpe Church. A large edifice located just off the seafront in Great Yarmouth is officially called the Norfolk Naval Pillar but is also known as Nelson's Monument and the Britannia Monument. It is 144 feet (44 metres) high and contains 217 steps which lead to a small viewing area at the top. The foundation stone was laid in 1817 and it was opened to the public two years later. Originally built on open land beside a racecourse, it has long been surrounded by industrial units which do little to enhance its visitor appeal. The monument is topped by a huge figure of Britannia which cost £892, paid for by Yarmouth Corporation. Most of the other monies were raised

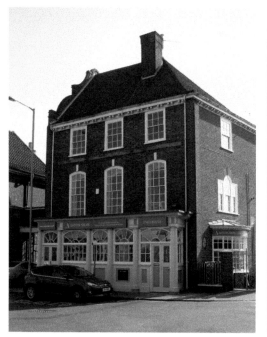
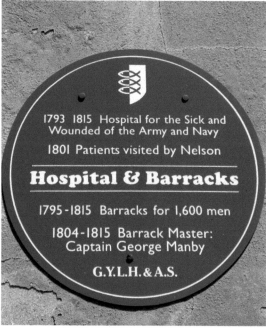

Left: The former Wrestlers Inn, Great Yarmouth. *Right*: Site of the old Naval Hospital, Great Yarmouth.

by public subscription, and the total cost was around £10,000 including a custodian's house which was demolished during the 1920s. Britannia faces inland instead of out to sea, which appears to have been deliberate rather than an error, as some believe. An acrobat named Charles Marsh fell from her shoulders while entertaining a large crowd in 1863 and was killed. This was not the first death at the monument as the surveyor, Thomas Sutton, died from a heart attack after climbing to the top on 1 June 1819. He was sixty-five years old and his gravestone can be viewed close to the main entrance of St Nicholas Minster in the town centre.

The monument's first custodian, from 1819 until his death at the age of eighty-two in 1867, was James Sharman, who was press-ganged into the Navy at the Wrestlers public house and was aboard *Victory* at the Battle of Trafalgar. Nelson's daughter, Horatia, was a visitor, as was Charles Dickens, who based a character in one of his novels on Sharman (*see* chapter 'Literary Locations and Inspirations'). The monument was restored in 2005 to mark the bicentenary of Nelson's death but the interior is only accessible to the public on open days.

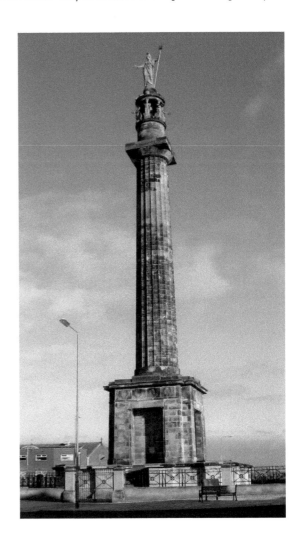

The Norfolk Naval Pillar, Great Yarmouth.

Also in Great Yarmouth, visitors to the Time and Tide Museum can see an early head of Britannia on display. Norwich Castle Museum houses several Nelson-related artefacts including a monument by John Ninham which contains the St Vincent sword donated to the city by Nelson in 1797.

Edith Cavell – Norfolk Nurse and Patriot

The life of Edith Louisa Cavell began on 4 December 1865 in the village of Swardeston near Norwich, where her father, the Reverend Frederick Cavell, served as vicar for over forty-five years. She is depicted in a stained-glass window installed in 1917 at St Mary's Church and hers is the first name on the First World War memorial in the churchyard.

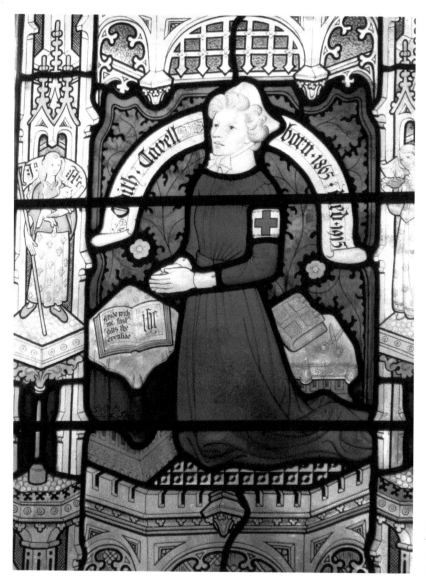

Edith Cavell window, St Mary's Church, Swardeston.

The eldest of four children, Edith began training to be a nurse in December 1895. After working at several British hospitals she became matron of Belgium's first nurses' training school in 1910. In the summer of 1914, while in Norwich visiting her recently widowed mother, Louisa, she learned of the imminent outbreak of the First World War and returned to Belgium straight away. The pair never met again.

The Red Cross took control of the Brussels nursing school and Nurse Cavell and her staff treated and saved the lives of wounded Allied, German and Austrian soldiers, without prejudice. She was arrested along with many others on 5 August 1915, for allegedly helping soldiers escape from occupied Belgium. A trial took place on 7 October 1915 and all of the accused were found guilty apart from eight. Nurse Cavell and four others were sentenced to death; the rest were given sentences of hard labour or imprisonment. She was informed on 11 October that she would be executed early the following morning and was given the Holy Sacrament by an Irish Anglican chaplain on the evening before her death. She reportedly sang the hymn 'Abide with Me' and wrote several letters including one to her mother. Finally, she entered the dates of her arrest, imprisonment, trial, and even her death, in her prayer book. Her last written words were: 'Died at 7am on October 12th 1915'.

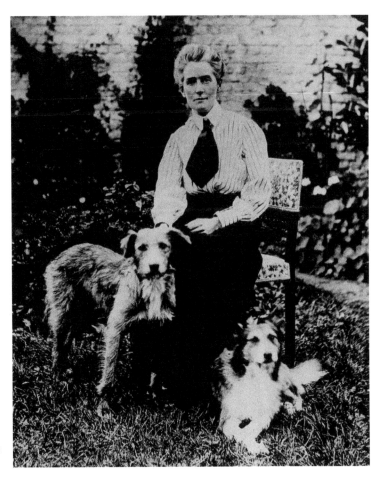

Edith Louisa Cavell.
(Belgium c. 1914; Wellcome
Collection CC BY-4.0)

Miss Cavell, who died wearing her blue nurse's uniform, was blindfolded and tied to a post before her execution at the National Shooting Range in Schaerbeek, Brussels. Her body was hastily buried and a simple wooden cross marked her temporary grave. The execution by firing squad of a British nurse working in a Red Cross hospital created an almost universal outcry. Nurse Cavell's death was depicted on posters and stamps and during the months that followed there was a large rise in the number of men enlisting in the British armed forces. From being unknown to the general public during her lifetime, in death she had arguably become as famous as another great British nurse, Florence Nightingale. Following the end of the First World War in November 1918, her body was exhumed and reburied at Norwich Cathedral on 19 May 1919. The first part of the funeral service was held at Westminster Abbey and the second in Norwich later the same day. Edith Cavell's grave underwent extensive refurbishment including a new headstone in spring 2016.

A memorial designed by Henry Alfred Pegram was unveiled by Queen Alexandra in Tombland, Norwich, on 12 October 1918, the third anniversary of the Norfolk nurse's death. The inscription reads: 'Edith Cavell Nurse Patriot and Martyr'. The memorial was moved a short distance to its present position close to Norwich Cathedral's Erpingham Gate in 1993. The restored railway carriage which brought her body from Dover to London is normally kept at Bodiam Station in Kent, but between 5 and 17 October 2015 it was on display in the centre of Norwich. Appropriately known as the Cavell Van, the interior has a faithful replica of her coffin and information boards recording its history.

 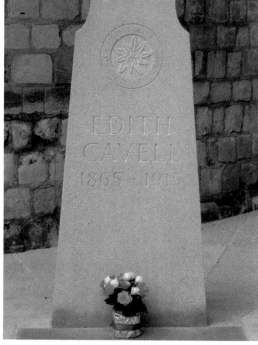

Left: Edith Cavell's monument, Norwich. *Right*: Her new headstone. (Courtesy of Norwich Cathedral)

The Cavell Van in Norwich, October 2015.

A number of films have been produced about her life and death, the best-known being *Nurse Edith Cavell* starring Anna Neagle in the title role. She was a modest woman who insisted she was just doing her duty but, inevitably, much of her life's work is overshadowed by the brutal nature of her death.

Anna Sewell – Best-selling Author

Anna Sewell, one of Norfolk's most famous daughters, was born at 26 Church Plain, Great Yarmouth. The property was largely constructed in 1641, though the present distinctive facade was not added until 1932. Now named Anna Sewell House, over the years it has been used for various purposes including a museum dedicated to her memory. It is currently run as a tea and cake shop and a simple plaque on the front of the building states: 'Anna Sewell, the authoress of Black Beauty, was born here on March 30th 1820'.

Anna was born into a Quaker family as the first child of best-selling children's author Mary Sewell (née Wright) and her husband Isaac. Much of Anna's life was spent outside of Norfolk and while living at Palatine Cottage in Stoke Newington fate cruelly intervened when she suffered a bad fall while running home from school in heavy rain. She was

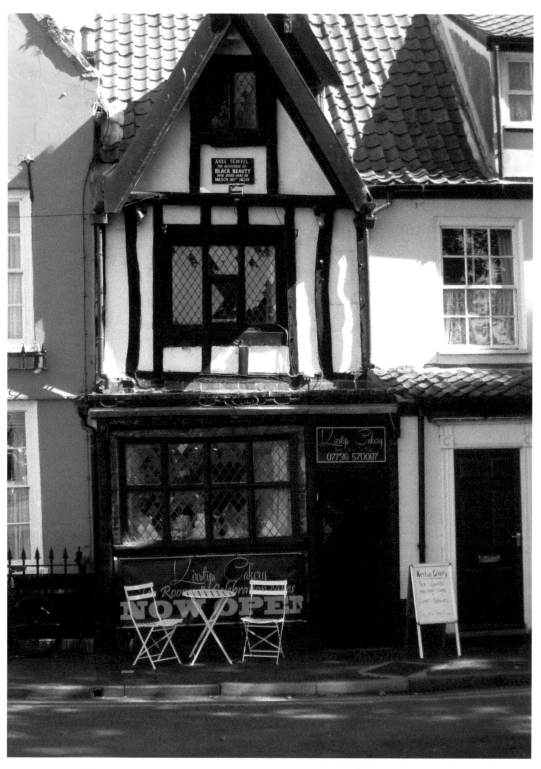

Anna Sewell House, Great Yarmouth.

around fourteen years old and the fall resulted in injuries to her feet which caused her much intermittent pain for the rest of her life. Many 'cures' were tried unsuccessfully and some may have made matters worse. Anna visited spas in England and Germany and met the great poet Alfred (later Lord) Tennyson (1809–92) at a spa in the late 1840s. They apparently got along well together and Tennyson presented her with a signed portrait of himself. At that time he was already well on his way to superstardom while she was many years away from achieving fame and recognition as an author.

Following the death of her brother Philip's first wife, Sarah, on 23 December 1866, Anna and her parents returned to Norfolk to help look after his children. They bought a house in Spixworth Road, Old Catton, near Norwich, where Anna wrote her masterpiece. Her bedroom overlooked a deer park on the opposite side of the road, which may have helped inspire her. The deer are long gone but horses still graze there. Anna's health worsened in early 1871 and she spent much of her remaining time either in bed or lying on a sofa. A doctor was of the opinion that she may have had less than two years to live and this pessimistic prognosis spurred her on to complete what she modestly called 'my little book'.

Anna Sewell died at the age of fifty-eight due to a combination of tuberculosis and hepatitis at her home in Old Catton on 25 April 1878. Like her birthplace, it is now known as Anna Sewell House and carries a plaque in memory of her. It is privately owned and not open to the public. She was buried at the Quaker Burial Ground behind the former Friends' Meeting House in the village of Lamas, which adjoins Buxton. After lying

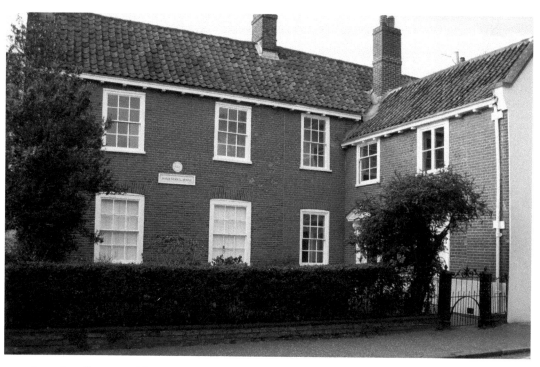

Anna Sewell House, Old Catton.

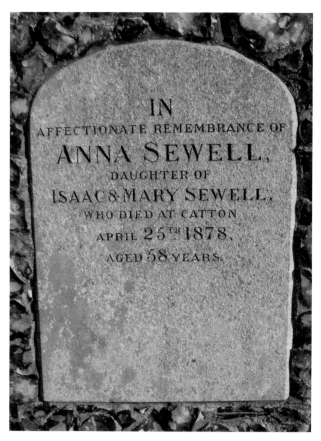

IN
AFFECTIONATE REMEMBRANCE OF
ANNA SEWELL,
DAUGHTER OF
ISAAC&MARY SEWELL,
WHO DIED AT CATTON
APRIL 25TH 1878,
AGED 58 YEARS.

Anna Sewell's gravestone, Lamas.

undisturbed for over a century, her peace was rudely interrupted when much of the burial ground was bulldozed in September 1984, allegedly without prior permission or consultation. This caused an outcry locally and the repaired gravestones of Anna, her parents, and her uncle and aunt were later set in a wall by the roadside where they can be viewed. During her lifetime Anna was known mainly as successful writer Mary Sewell's sickly daughter. Even in the 1930s, a sign on her birthplace focussed on the fact that Mary Sewell once lived there, with Anna's name appearing at the bottom. The passing of time has completely turned the tables and Anna's fame has totally eclipsed that of her mother. (*See* also 'Literary Locations and Inspirations' for places specific to *Black Beauty*).

Howard Carter – Norfolk's Egyptologist

The disparate worlds of ancient Egypt and deepest Norfolk rarely collide, but they came together with a bang a century ago due to one of the greatest-ever archaeological finds.

One of eleven children, Howard Carter was born in London but raised in Swaffham where his parents, Samuel and Martha, were born. As a boy he became interested in Egyptology after visiting Didlington Hall, the home of Lord and Lady Amherst, which was located 8 miles from Swaffham but was demolished in 1952. Lord Amherst had amassed a fine collection of Egyptian artefacts, which fired young Howard's imagination.

In 1891, at the age of just seventeen, Carter started working in Egypt and his long association with Lord Carnarvon began in 1907. He had just started excavations in the Valley of the Kings in 1914 when the First World War broke out. On returning to Egypt in late 1917, Carter resumed his search for the tomb of King Tutankhamun but progress was slow. After Lord Carnarvon agreed to finance one last season of excavations in 1922, steps to the tomb were finally discovered in November of that year. After making a tiny viewing hole in the outer doorway, Carter was asked by Carnarvon if he could see anything inside. The Norfolk man replied: 'Yes, wonderful things!'

After entering the burial chamber and discovering Tutankhamun's sarcophagus intact in February 1923, Carter announced his remarkable find to the world but did not finish cataloguing the tomb's contents until nine years later. Lord Carnarvon died from blood poisoning in Cairo on 5 April 1923, giving rise to the legend of the Curse of Tutankhamun. Carter became world-famous and gave illustrated lectures in Britain, Europe and the USA. He died at the age of sixty-four at 49 Albert Court in Kensington, London, on 2 March 1939, and was buried in Putney Vale Cemetery.

Howard Carter is well remembered in his home town and has his own room in Swaffham Museum, on London Street in the town centre. It contains Egyptian artefacts

Swaffham Heritage Museum.

along with information about the Carter family including his cousin Harry Carter (1907–83), who was a well-known local sign maker. The Carter Gallery was extensively upgraded in 2022 to mark the centenary of the discovery of Tutankhamun's tomb.

Elizabeth Fry – Prison Reformer

Born Elizabeth Gurney at Gurney Court, Norwich, on 21 May 1780, Fry was a leading campaigner for prison reform. She came from a Quaker family and her father, John Gurney, was a partner in Gurney's Bank. Her mother Catherine, who passed away when Elizabeth was at the age of twelve, was part of the Barclay banking dynasty and the two organisations later merged. When Elizabeth was a child the family moved to Earlham Hall, which still exists as part of the University of East Anglia.

After marrying banker and fellow Quaker Joseph Fry at the Friends' Meeting House in Upper Goat Lane, Norwich, on 19 August 1800, Elizabeth and her new husband moved

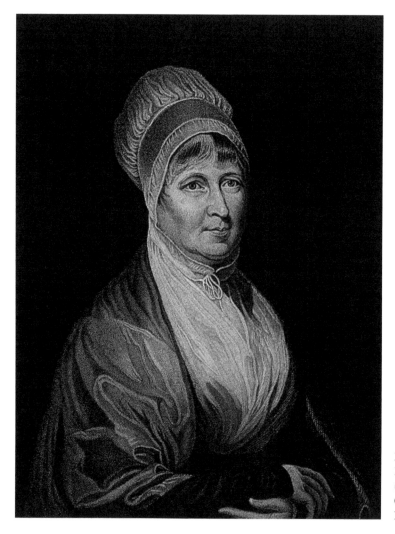

Portrait of Elizabeth Fry. (Wellcome Collection CC BY-4.0)

to London. The couple had eleven children, all of whom reached adulthood apart from a daughter, Elizabeth, who died at the age of five in 1816. Fry's first visit to Newgate Prison in 1813 was the start of her crusade to improve prisoners' living conditions, particularly those of women and children. She spent many years helping to educate and rehabilitate prisoners and was also a fervent anti-slavery campaigner. Fry's causes were supported by Queen Victoria and her work helped inspire a young Florence Nightingale.

Elizabeth Fry died on 12 October 1845 after suffering a stroke and was buried in the Friends' Burial Ground at Barking. Her legacy lives on and her likeness appeared on the Bank of England £5 note between 2001 and 2016. A plaque in memory of her was unveiled at the Friends' Meeting House in Norwich in 2007. Another plaque is attached to a wall behind a locked gate at the entrance to her birthplace, Gurney House in Gurney Court, off Magdalen Street in Norwich.

Harriet Martineau (1802–76), an author, journalist and social reformer, was also born in Gurney House and her plaque can be seen there next to Mrs Fry's.

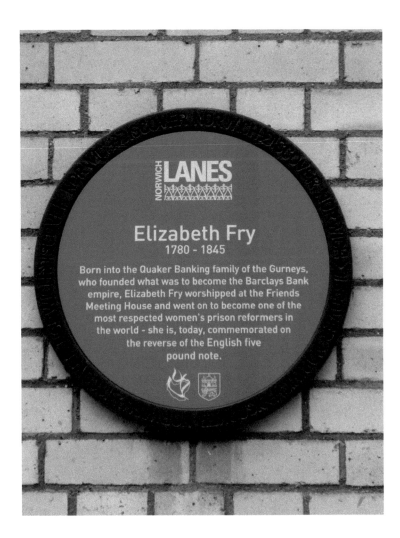

Elizabeth Fry's plaque, Friends' Meeting House, Norwich.

Julian of Norwich – Anchoress and Pioneering Author

A small sealed room in a Norwich church was the unlikely setting for the creation of the first English-language book written by a woman. The real name of the medieval recluse and author of *Revelations of Devine Love* remains a mystery but she has become internationally known as Julian of Norwich.

We first hear of Julian in 1373 when, at the age of thirty, she became seriously ill and received the Last Rites. As she hovered between life and death she experienced a total of sixteen vivid visions of Jesus Christ. Following her recovery she vowed to dedicate the rest of her life to God and live in solitary confinement as an anchoress at St Julian's Church. She is named after the church, not vice versa, but there is some disagreement as to whether she was a nun or a laywoman.

The original version of *Revelations of Devine Love* (the 'Short Text') was started shortly after Julian had her visions. An extended version (the 'Long Text') was written later and may have taken years or even decades to complete. Julian's detailed reinterpretations of her visions ran to eighty-six chapters and both versions are now regarded as important theological works. Some of her personal beliefs clashed with contemporary Catholicism, not least the assertion that God and Jesus embodied elements of both father and mother.

St Julian's Church, Norwich.

Julian believed that God loved everybody and that 'all shall be well and all manner of thing shall be well'. Her work was first printed in the late seventeenth century but did not gain widespread interest and critical acclaim until the early twentieth century. Originally written in the local dialect of her day, the text has been modernised over the centuries and has been translated into a number of languages.

Julian may have taken part in services via a small window between her cell and the main church and probably conversed with others through another window overlooking the churchyard. She may have died around 1416, though there is a record of a payment made to an anchoress at St Julian's Church in 1429. The original cell was demolished after the Reformation but a replica was constructed when the church was rebuilt in 1952 following severe bomb damage during the Second World War. Unlike Julian, modern pilgrims and visitors can enter and leave as they please. St Julian's Church is located beside an alley linking King Street and Rouen Road. The Julian Centre, situated next to the church, is an information centre and library devoted to her life and work. She is represented in stained-glass windows in Norwich Cathedral's Bauchan and St Saviour's chapels. A statue by Norwich sculptor David Holgate, commissioned to mark the start of the new millennium, stands on the left of the main doorway at the front of Norwich Cathedral. The Lady Julian Bridge across the river Wensum in Norwich was opened in 2009 and cost £2.5 million to construct. There is also a colourful depiction of Julian inside St Andrew and St Mary's Church at Langham in North Norfolk.

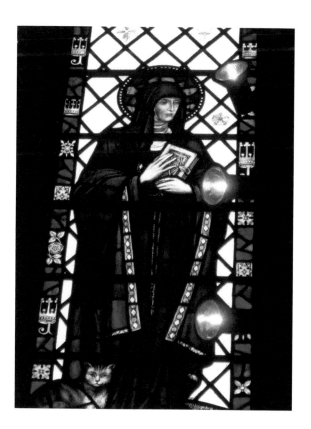

Julian window, St Saviour's Chapel, Norwich Cathedral. (Courtesy of Norwich Cathedral)

Fellow Norfolk mystic and seer of visions Margery Kempe (*c*. 1373–1440) was born in Bishop's (now King's) Lynn and despite probably being only semi-literate was the author of the first known autobiography to be written in English. *The Book of Margery Kempe*, which she dictated to a scribe, was lost for centuries before being rediscovered in the 1930s. It records a meeting with Julian in Norwich around 1414, which according to Kempe lasted for several days. Unlike Julian, Kempe went on many pilgrimages and is said to have had at least fourteen children.

Thomas Paine – Writer and Revolutionary

Born on 9 February 1737, Thomas Paine is probably Thetford's most famous son. He was strongly opposed to the monarchy and actively supported both the French Revolution and American Independence. He was also an early anti-slavery and pro-women's liberation campaigner.

A statue of Paine was unveiled in 1964 in front of King's House on King Street in Thetford town centre, but it was not welcomed by all. An inscription on the plinth states that it was 'presented to the people of Britain by the Thomas Paine Foundation New York, USA'. Extracts from two of his most famous works, *Rights of Man* and *The Age of Reason*, also adorn the plinth. The statue holds an inverted copy of *Rights of Man* in one hand and a quill in the other. Paine's birthplace on Whitehart Street was demolished long ago and the site is now occupied by the appropriately named Thomas Paine Hotel. Two plaques can be seen on the exterior walls, and a nearby road is named Thomas Paine Avenue.

Paine emigrated to America after meeting Benjamin Franklin in 1774, and worked as a journalist. He was appointed managing editor of *Philadelphia Magazine* and also published a very popular pamphlet called *Common Sense* in January 1776, which sold 150,000 copies in its first year. Paine urged America to break free from British rule and the pamphlet is considered to have been highly influential during the War of Independence. He then served under General George Washington, who later became the first President of the United States. After a brief career in American politics, Paine became a bridge designer before publishing *Rights of Man* in two volumes during 1791/2. He visited France in 1792 and supported the French Revolution, though he opposed the execution of Louis XVI and others. Paine was arrested on a charge of treason in 1793 but was spared execution. *The Age of Reason*, published in three volumes between 1794 and 1807, was critical of the Christian Church and questioned some Biblical texts. The book sold better in America than in Britain, though Paine's involvement in the French Revolution and a public spat with George Washington saw his popularity fall on both sides of the Atlantic.

Thomas Paine died in New York City on 8 June 1809 and was buried on his farm in New Rochelle after a wish to be interred in a Quaker graveyard was denied. Ten years later, a radical British journalist named William Cobbett dug up Paine's remains and shipped them to England for reburial. This never happened and the bones were discovered still at Cobbett's house after his death in 1835. What happened to them after that is unclear but various unsubstantiated claims have been made. An Australian businessman was alleged to have acquired Paine's skull in the 1990s and the Thomas Paine National Historical Association in New Rochelle is said to hold other remains.

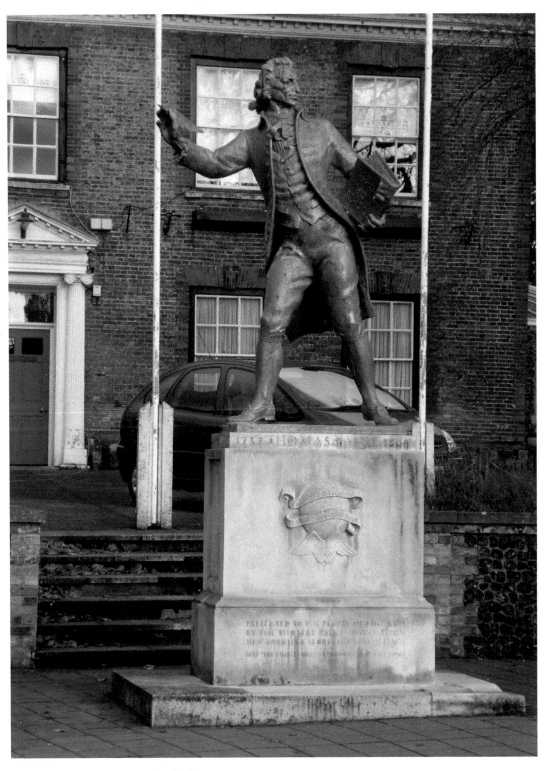

Thomas Paine's statue, Thetford.

Sir Henry Rider Haggard – Celebrated Novelist

One of the most successful novelists of the late nineteenth and early twentieth centuries, Henry Rider Haggard was born at Bradenham in Norfolk on 22 June 1856. Among his best-known works are *King Solomon's Mines* (1885), *She: A History of Adventure* (1886), *Allan Quatermain* (1887), *Jess* (1887) and *Ayesha: The Return of She* (1905). With over 25,000 copies sold within three months of its publication, *She* was an immediate success and total sales are claimed to have surpassed the 80 million mark.

Rider Haggard's novels were mainly adventure stories often set in Africa, and he is said to have originated the 'Lost World' genre which inspired many other writers. The author's native Norfolk took a back seat to more glamorous locations but did feature in some of his non-fiction work. He was a keen farmer and wrote about his estate and agriculture in general. Rider Haggard lived at Ditchingham House on Norwich Road, Ditchingham, on the Norfolk side of the boundary with Suffolk. The building still exists but has been divided into private apartments.

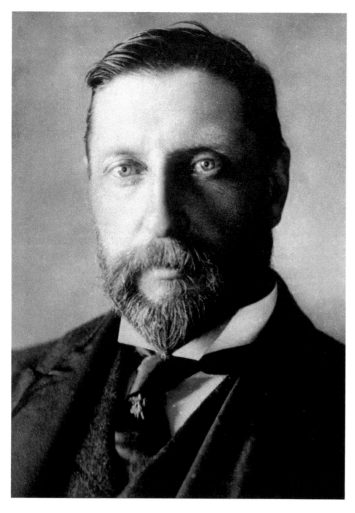

Henry Rider Haggard *c.* 1905.
(Bain News Service, publisher)

 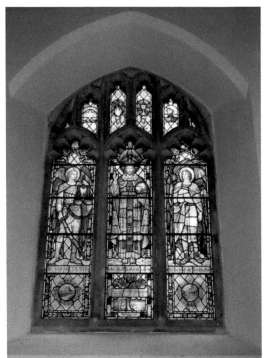

Left: Ditchingham Church. *Right*: Rider Haggard window, Ditchingham Church.

Following his death on 14 May 1925 at Marylebone in London, Rider Haggard's ashes were buried at St Mary's Church, Ditchingham. His last book, *Belshazzar*, was completed shortly before his death and published posthumously in 1930. Several books have been adapted for film, including a number of different versions of *King Solomon's Mines* and *She*. Sir Henry's youngest daughter, Lilias Rider Haggard MBE (1882–1968), commissioned a stained-glass window in his memory at St Mary's Church and is also buried there. She published several books including *The Cloak That I Left*, a biography of her father.

Archbishop Matthew Parker

According to folklore the term 'nosy (or nosey) parker' derives from a sixteenth-century son of Norwich who became Archbishop of Canterbury. Matthew Parker was born in the city on 6 August 1504, and later served as chaplain to King Henry VIII and Queen Anne Boleyn. He even had a walk-on part in Kett's Rebellion of 1549 (*see* 'Battles and Rebellions'), when he visited the rebels' camp on Mousehold Heath but failed to convince them to lay down their arms. Against the odds his life was spared and he was allowed to leave uninjured.

Ten years after this incident, Parker was appointed Archbishop of Canterbury under the new Protestant monarch Queen Elizabeth I and remained in the role until his death on 17 May 1575. It was during this period that he is said to have acquired the nickname

The Parker family grave, St Clement's churchyard, Norwich.

'nosy' due to his keen interest in the early Christian Church and the behaviour of some of the clergy. In contemporary images Parker is shown with a long and prominent nose, prompting suggestions that this may have contributed to his nickname. However, there appears to be no actual evidence that the term has anything to do with Matthew Parker. The first printed reference to 'nosy parker' probably appeared in the *Belgravia* magazine as late as 1890, and this was not in connection with the long dead archbishop.

Whether 'nosy' or not, Parker – who is also credited with helping to reinvent King Alfred as a great national hero – was laid to rest in the chapel of Lambeth Palace. His parents, William and Alice Parker, lie in an elaborate grave in the overgrown churchyard of St Clement's Church near Fye Bridge in Norwich.

Captain George Vancouver – Explorer

Born in King's Lynn on 22 June 1757, George Vancouver was a Royal Navy captain who gave his name to Vancouver, Washington, USA, the city of Vancouver in British Columbia, Vancouver Island, and mountains in New Zealand and on the border between the United States and Canada.

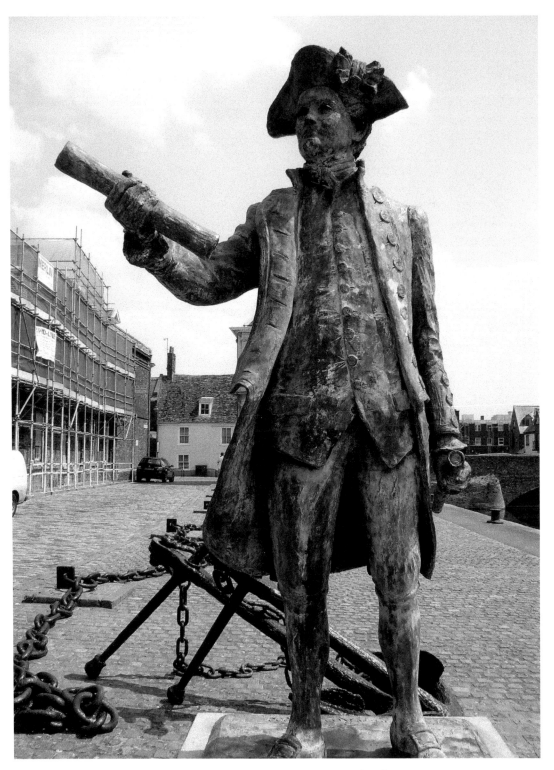

Captain Vancouver's statue, Purfleet Quay, King's Lynn. (Immanuel Giel)

The young George Vancouver enlisted in the Royal Navy at the age of thirteen and sailed on two voyages with Captain James Cook between 1772 and 1780. From 1791 to 1795, he explored and mapped areas of North America, the Hawaiian Islands and parts of the Australian coastline. On returning to Britain and taking early retirement from the Royal Navy, Vancouver chose Petersham in London as his new home rather than his native Norfolk. Thomas Pitt, 2nd Baron Camelford, who had served under Vancouver before being disciplined and finally dismissed by him, challenged his former captain to a duel, which he declined. Supported by his cousin, Prime Minister William Pitt the Younger, Thomas Pitt continued to publically vilify Vancouver and physically attacked him on Conduit Street in London in 1796.

George Vancouver died aged just forty on 10 May 1798, possibly due to kidney failure or a hyperthyroid condition. He was buried in the churchyard of St Peter's in Petersham. In King's Lynn he is remembered with a statue in front of the old Custom House on Purfleet Quay. Vancouver Avenue and the Vancouver Quarter shopping centre also bear his name.

Amelia Opie – Author, Poet and Abolitionist

Amelia Opie (née Alderson) was born in Norwich on 12 November 1769 and became one of the city's most prolific writers. Her father, James Alderson, was a local physician and she had a privileged upbringing, though her mother, also named Amelia, died when she was fifteen years old. In 1798 she married artist John Opie, who painted a vivacious portrait of his new wife the same year. Amelia was widowed nine years later and never remarried.

After anonymously publishing a book titled *Dangers of Coquetry* in 1790, Opie went on to produce many novels and poems under her own name. Her novel *Father and Daughter* was published in 1801 and was followed by *Adeline Mowbray* three years later. Other novels include *Simple Tales* (1806), *Tales of the Heart* (1818) and *Madeline, A Tale* (1822). A twelve-volume set called *Miscellaneous Tales* was published in 1845–47. Opie's collection of poetry simply titled *Poems* was first released in 1802 and was reprinted several times. Other collections include *The Warrior's Return and Other Poems* (1808) and *Lays for the Dead* (1834). She also wrote a biography of her late husband, *Memoir of John Opie*, in 1809.

Amelia Opie, who became a Quaker in 1825, was strongly against slavery and went on to be an influential abolitionist. She bravely tackled the subject in her poem *The Black Man's Lament* in 1826, and together with Anna Gurney formed the Norwich Ladies Anti-Slavery Society. They presented a petition to parliament and Opie attended the World Anti-Slavery Convention in London in 1840. She did much work for charity and was well travelled, but passed away peacefully in her home city at the age of eighty-four on 2 December 1853.

Amelia Opie was buried at the Gildencroft Quaker Burial Ground off Chatham Street in Norwich. Today it is overgrown but some gravestones can be glimpsed among the long grass.

Gildencroft Quaker Burial Ground, Norwich.

J. J. Colman – The 'Mustard King'

Jeremiah James Colman was born on 14 June 1830 and was the third member of the Norfolk mustard-making dynasty to run the family business. He famously stated that he made his fortune 'from the mustard that people throw away on the side of their plate'. For many years Colman's were based at Stoke Holy Cross near Norwich. They purchased the existing Stoke Watermill in 1814 and later added wind and steam mills at the 2-acre site. At its peak around 200 Colman employees worked at Stoke Holy Cross. It was Jeremiah James Colman who moved the company's base to the newly built Carrow Works in Norwich during the 1850s. He lived on-site at Carrow House close to Carrow Priory ruins, and the workforce numbered over 2,000 individuals by the early 1890s. Much later, Colman's Mustard became part of the Unilever group, who closed the Carrow Works in May 2020 after attempts to keep it open failed. Carrow House still exists, as does Stoke Mill, which was converted to a restaurant in the 1970s and is still used for that purpose today.

J. J. Colman married Caroline Cozens-Hardy in 1856 and the couple had six children. He was the city's sheriff in 1862 and mayor in 1867. A Liberal Party politician, he was MP

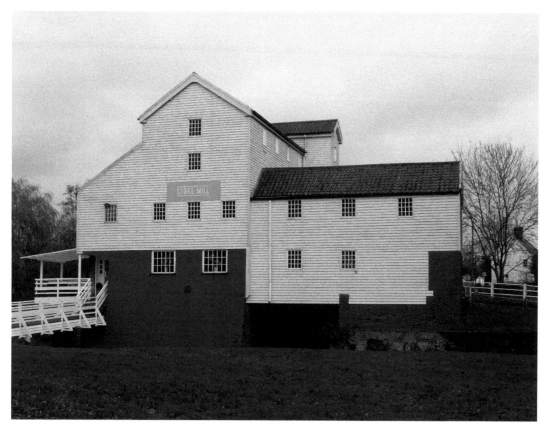

Stoke Mill, Stoke Holy Cross.

for Norwich from 1871 to 1885 and again from 1886 to 1895. Colman built houses for his employees and acquired a reputation as a kind and generous philanthropist. He died on 18 September 1898 and was buried in Norwich's Rosary Cemetery. The city is said to have ground to a standstill on the day of his funeral.

Other prominent Norfolk politicians include Sir Robert Walpole (1676–1745), who was born in the village of Houghton. He is generally recognised as Britain's first prime minister and served in that role from 1721 to 1742. He was buried in St Martin's Church in the grounds of Houghton Hall.

Thomas Coke (1754–1842) was Member of Parliament for Norfolk for many years and, like Walpole, was a member of the Whig party. Known as 'Coke of Holkham', he was an agricultural reformer and inherited the Holkham Estate, which is still owned by his descendents.

Pocahontas' 'Secret' Norfolk Sojourn

It is surprising but true that one of history's most famous but enigmatic characters spent part of her short life in Norfolk. The legendary Pocahontas, daughter of Chief Powhatan, was born *c.* 1596 in Virginia. Her real name was Matoaka and Pocahontas was a childhood

nickname. According to Captain John Smith – a co-founder of the Jamestown colony – she saved his life in 1607 by warning him that her father planned to kill him. The Disney movie *Pocahontas* (1995) portrays the pair as lovers but in reality Smith was about twenty-eight years old at that time and she was only eleven.

In 1613, during the first Anglo-Powhatan War, the British took Pocahontas prisoner and held her for ransom. She converted to Christianity and changed her name to Rebecca. In April 1614, she married Norfolk man John Rolfe, with whom she had a son named Thomas the following year. John, Rebecca and Thomas Rolfe travelled to England in 1616 and are believed to have briefly stayed at the Rolfe family home, Heacham Hall in

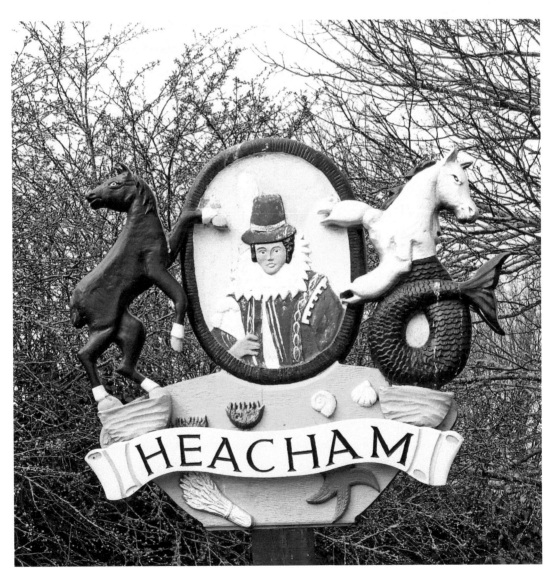

Heacham village sign. (Photo © Adrian S Pye, CC-BY-SA/2.0, geograph.org.uk)

North Norfolk. She supposedly planted a mulberry tree there which still exists, unlike the hall itself which was demolished in 1941 following a fire. A local copy of the King James Bible dated 1617 is said to have connections with her and St Mary's Church contains a memorial. Heacham village sign carries a depiction of Pocahontas, who spent the last ten months of her life in England and attended the court of King James I.

Rebecca Rolfe died at the age of twenty-one or twenty-two in Gravesend, Kent, in March 1617. The Rolfe family were about to leave England when she was taken ill and John Rolfe returned to Virginia a widower. He was killed during unrest there in 1622. The couple's son, Thomas, was raised at Heacham Hall by his uncle, Henry Rolfe, but he too returned to Virginia in 1635 and passed away *c.* 1680. His descendents still live in the USA.

2. Battles and Rebellions

Boudicca's Last Stand

Nearly 2,000 years ago, the Iceni kingdom covered an area roughly equivalent to present-day Norfolk, along with parts of Cambridgeshire and Suffolk. According to legend it was ruled by a formidable warrior queen known to generations of schoolchildren as Boadicea. Today she is generally known in English as Boudicca or Boudica, though many other spellings of her name have been used down the centuries.

Boudicca is believed to have been of royal blood and was probably born near the modern city of Norwich. She was the wife of Prasutagus, King of the Iceni people, who revolted against the Roman occupiers in AD 47 but suffered a devastating defeat. Despite this, the Iceni remained independent until the death of Prasutagus in AD 60, when their lands and possessions were taken by force. Boudicca was said to be a tall, harsh-voiced woman with waist-length tawny-coloured hair. After her husband's death she was lashed and her two daughters were raped. She then led a huge revolt in AD 60 or 61, when the Iceni joined forces with other native groups including the neighbouring Trinovantes. While the main Roman army was busy crushing unrest in Wales, Boudicca and her allies attacked Camulodunum (present-day Colchester) and completely destroyed it. Resistance from a Roman legion was overcome by the massed ranks of Britons, who then marched on to Londinium (modern London) and burned it to the ground. Next they took Verulamium (now St Albans), torturing and killing the inhabitants as they had at the previous locations. It is estimated that a total of 70,000–80,000 people were killed by the Britons.

Following these victories, Boudicca's army was met by several legions of Roman infantry together numbering nearly 10,000 men. The Romans, led by Gaius Suetonius Paulinus, were heavily outnumbered, though claims that the Britons were up to 250,000 strong are thought to be exaggerated. According to the victors around 80,000 rebels, including men, women and children, died that day along with 400 Roman soldiers. The battle may have taken place near Wroxeter in Shropshire on a road now called Watling Street. Other possible sites include Atherstone, Warwickshire; High Cross, Leicestershire; Kings Norton near Birmingham; or Cuttle Mill in Northamptonshire. Boudicca herself is said to have survived the slaughter but died soon after, either due to illness or suicide by poisoning. Her age and final resting place are not recorded, though she is believed to have received a royal Iceni burial. An area on Parliament Hill in London was traditionally known as Boadicea's Grave, but excavations on the site in 1894 found no trace of a burial. A grand statue called *Boadicea and Her Daughters*, depicting the three women on a chariot pulled by two galloping horses, was erected near to the Houses of Parliament in 1902.

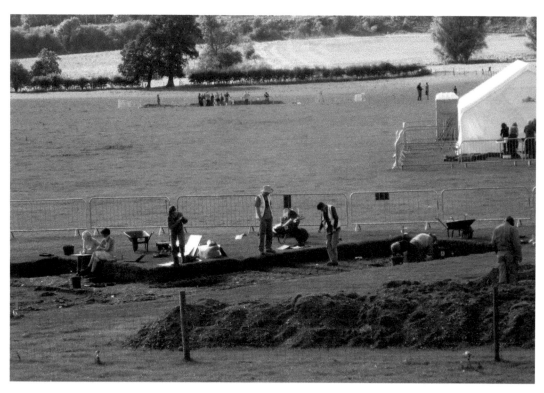

Above: Archaeological dig at Caistor St Edmund, 2010. *Below*: The now demolished Iceni Village, Cockley Cley, 1999.

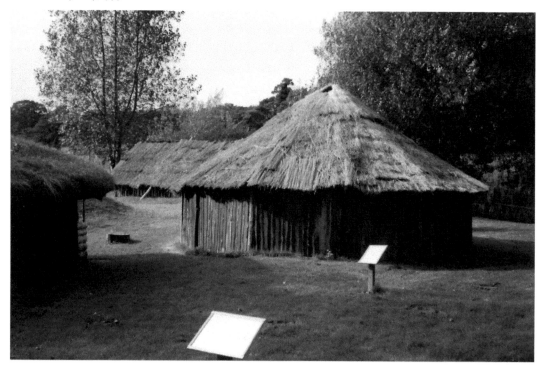

Following Boudicca's death, the defeated Iceni continued to live in East Anglia under Roman control. Their main base was Venta Icenorum, located at Caistor St Edmund near Norwich, which was probably established around AD 70 and is believed to have been a trading, administrative and cultural centre. The name means 'Marketplace of the Iceni' and the town was occupied until the early sixth century, though by this time some of the buildings were no longer standing. At its peak the town covered an area of around 120 acres and had running water, baths, temples, shops, villas and an amphitheatre. Venta Icenorum is one of just three known Roman towns in Britain not to have been built over and was rediscovered from the air in 1928. Major archaeological digs took place between 2009 and 2012 under the direction of the University of Nottingham and the Caistor Roman Project (CRP). The most recent excavation was during the summer of 2021 and the site is open to the public.

Other Iceni settlements around 2,000 years ago included one at Cockley Cley, 3 miles south-west of Swaffham. Between 1975 and 2014, a replica Iceni Village built by Sir Peter Roberts on the site of ancient foundations was open as a visitor attraction but has since been demolished. A replica Iceni chariot is on display at Norwich Castle Museum and a 36-mile (58-km) long walk between Norwich and the town of Diss in South Norfolk is called Boudicca's Way.

Robert Kett and the Norfolk Rising

Reminders of the Norfolk Rising or Kett's Rebellion of 1549 can still be seen in several locations in the county. The seeds of rebellion were sown in the market town of Wymondham (pronounced 'Windham'), where fifty-seven-year-old farmer and landowner Robert Kett was a well-known figure. Unrest was growing locally due to many landowners, Kett included, erecting fences and hedges around their fields to prevent poor people from grazing their animals there. When a group of men began destroying Kett's fences on Monday 8 July 1549, Kett not only assisted them but offered to become their leader. What happened next was to change the course of local history and put Kett and the rebels on a collision course with the established hierarchy.

Robert Kett and his unlikely band of men started their journey to Norwich on 9 July after assembling at Kett's Oak, which still exists beside the B1172 between Wymondham and Hethersett. Having arrived outside Norwich on 12 July and being refused permission to march through the city, Kett's army went round the perimeter on their way to Mousehold Heath, a large area of heath and woodland overlooking the city. They camped at what is now named Kett's Heights, just off the present-day Kett's Hill, and took over Surrey House, the empty former home of the late Earl of Surrey who was put to death some years earlier. Kett himself made a base at the disused St Michael's Chapel nearby, which was nicknamed 'Kett's Castle'. Little remains of the chapel apart from a piece of stone wall, though more extensive remains date from a later period. This area is now landscaped and open to the public. It provides good views of the city, still dominated by Norwich Cathedral as it was in his time.

For nearly seven weeks there may have been more people at the rebels' camp than in Norwich itself, which was then home to around 12,000 citizens and the second largest city in England. Meetings were held under the Oak of Reformation, which survived into

Kett's Heights, Norwich.

the twentieth century but no longer exists. A list of grievances and concerns called the 'Twenty-Nine Requests' was prepared, the best known being 'that all bond men may be made free'. After the document was sent to King Edward VI, a royal herald arrived at Mousehold Heath on 21 July, offering them a pardon providing they left the camp and returned to their everyday lives. Robert Kett rejected the King's pardon despite requests to reconsider from the Mayor of Norwich, Thomas Codd, and the future Archbishop of Canterbury, Matthew Parker. Kett's offer of a truce in exchange for access to Norwich was turned down. Now running low on food and other supplies, the rebels attacked Bishop Bridge on 22 July and met with little resistance on their way to the city centre. They stole food and broke into the historic Guildhall where they seized weapons and other military supplies. The mayor and other officials were taken prisoner at the rebels' camp.

A royal army made up of noblemen, local gentry and several hundred Italian mercenaries arrived in Norwich on 31 July but retreated the following day after its deputy commander, Lord Sheffield, was pulled from his horse and killed by a rebel called Fulke the Butcher. Sheffield was hastily buried in an unmarked grave in the churchyard of St Martin at Palace. A plaque set into a flint wall across the road from the church records his death. More than 300 rebels were killed during the fighting but Norwich remained

Above and below: Bishop Bridge, Norwich.

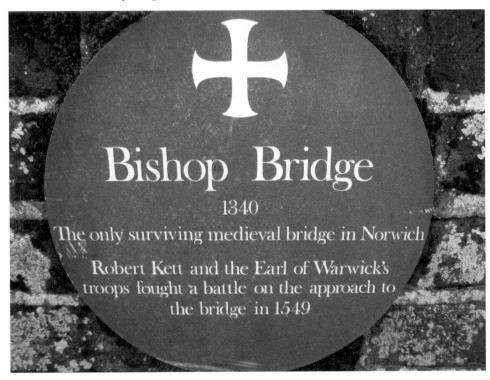

under their control until a second royal army entered the city on 24 August. This was a much larger force with up to 14,000 men at its disposal including cavalry. Kett and his men tracked its advance from the tops of churches and Norwich Cathedral spire. Over the next two days, hundreds of rebels were killed in fighting on the city's streets and many more were executed at the market cross. Led by the Earl of Warwick, who had a reputation as one of England's top soldiers, the troops took control of Norwich and forced the rebels back to their camp across the river. On the evening of 26 August, Kett and his men made the strategic error of leaving their lofty perch above the city and moving to lower ground. They still had a number of distinguished prisoners and these were positioned in full view of the approaching army in the hope that it may stem their advance. Cannons captured from Warwick's troops were placed around the new encampment and the rebels waited for the inevitable final battle to begin.

The site of the carnage on 27 August 1549 was a place called Dussindale or Dussin's Dale on the outskirts of the city, though there are several theories as to its actual location. Around 3,500 rebels were killed while the royal army lost in access of 200 men. According to one source, several of the rebels' prisoners were also killed but another account states that all prisoners survived the battle unharmed. Robert Kett escaped on horseback along with some of his men but only made it as far as Swannington, around 10 miles north-west of Norwich, where he was captured after stopping to rest for the night. Nine of the other leaders of the rebellion were hanged, drawn and quartered on 28 August, including

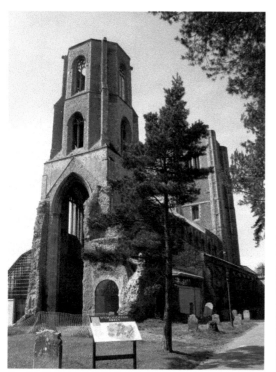
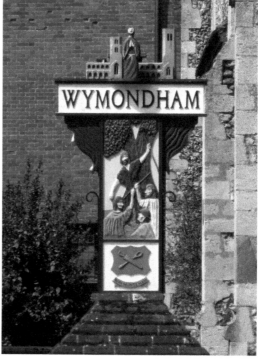

Left: Wymondham Abbey Church. *Right*: Wymondham town sign.

Fulke the Butcher and a man named Miles who was Kett's chief gunner. Their heads were displayed along the city walls and approximately 250 other rebels were hanged outside Magdalen Gates. Robert Kett and his brother William, who was at the age of around sixty-four, were imprisoned in the Tower of London on 9 September before being found guilty of treason and sentenced to death at their trial on 26 November.

Robert and William Kett were executed on 7 December 1549, Robert being hanged from the walls of Norwich Castle and his elder brother from the west tower of Wymondham Abbey. Robert Kett's body was finally cut down and buried in an unmarked grave many months later. He was anything but a typical felon or glamorous outlaw and a memorial tablet was placed at the main doorway of Norwich Castle in 1949. His execution is depicted in bronze on the doors of Norwich City Hall. Kett's Hill and Kett's Heights also keep his name alive in Norwich. A school in his home town is named after him and public houses also bear his name. The Wymondham town sign depicts the Norfolk Rising and is situated beside Becket's Chapel. Kett and the Rebellion have also inspired novels, plays, poetry and music. Eminent British classical composer Malcolm Arnold wrote a piece titled *The Robert Kett Overture (Opus 141)* in 1988.

The Battle of North Walsham (Peasants' Revolt)

Nearly two centuries before Kett's Rebellion, another uprising wreaked havoc across the land. The Peasants' Revolt began in the south-east of England and spread to most parts of the country in 1381. Low wages, controlled by the government, and a punitive early form of poll tax, were just two of the grievances of poor labourers who banded together to fight injustice. This soon led to violence, looting and rioting in many areas. Rebels somehow managed to gain access to the Tower of London and capture the Archbishop of Canterbury, Simon Sudbury, and the Treasurer, Sir Robert Hales. Both men were dragged outside and beheaded, a fate that befell Watt Tyler, leader of the rebels, a few days later.

Geoffrey Litster was a dyer from Felmingham near North Walsham. In some accounts he is known as John or Jack and his surname is spelt in a variety of different ways. Litster mobilised working men in Norfolk and they gathered on Mousehold Heath on 17 June 1381, just as Robert Kett and his followers would in much greater numbers in 1549. Sir Robert Salle is said to have died after being 'knocked on the head' when he attempted to converse with the rebels there. They then proceeded to take the city of Norwich and by all accounts left a trail of death and destruction in their wake. Local dignitaries and Church properties were targeted, along with written records relating to taxation and other matters. Great Yarmouth and several other towns also came under attack.

The Bishop of Norwich, Henry le Despenser (c. 1341–1406), vowed to end the revolt and assembled an army which travelled across Norfolk quelling pockets of resistance. A former soldier nicknamed the 'Fighting Bishop', le Despenser and his army finally caught up with the rebels at North Walsham Heath on 25 or 26 June. What happened next is uncertain but the rebels seem to have been no match for the Bishop's men. One account suggests that they surrendered quite early on and little blood was spilt. This is contradicted by other sources who state that many rebels were killed in battle or while attempting to escape. Local folklore tells that some sought refuge in the partially built

St Nicholas' Church in North Walsham but were burned to death when the Bishop's army set fire to it, though there is no hard historical evidence to support this. Litster was captured and hanged at Norwich Castle. His body was beheaded and cut into quarters, then the pieces were exhibited in Norwich, Great Yarmouth, King's Lynn and Thetford as a warning to other would-be rebel leaders.

The Battle of North Walsham was the final significant conflict during the Peasants' Revolt. Three crosses were erected to mark the battle site, one of which survives intact at Toff's Loke near Norwich Road. The stump of another can be seen close to a water tower. St Nicholas' Church, one of the country's largest parish churches, was completed shortly before the close of the fourteenth century and once had a splendid spire rising to a height of around 180 feet (55 metres). The tower partly collapsed on 16 May 1724, following several hours of bell-ringing the previous day, and again on 17 February 1836 during a gale. The ruined tower was made safe in 1939 and its unique appearance has helped make the church a visitor attraction.

St Nicholas' Church, North Walsham.

3. Historical and Modern Royal Connections

Norfolk has many historical royal connections going back to the time of Queen Boudicca, whose story was told in the previous chapter. Anne Boleyn, King John and others also have links with the county. The present Queen famously has a home at Sandringham and the late Princess Diana was born on the royal estate.

Anne Boleyn and Henry VIII

Local tradition has it that Queen Anne Boleyn was born and spent her early years at Blickling Hall near Aylsham. Her year of birth was probably around 1501 and her siblings, Mary and George, may also have been born there. The present building was constructed between 1619 and 1627 on the foundations of the original, which was previously owned by Sir John Falstoff (parodied by Shakespeare as Falstaff).

If the details of her early life are unclear, the events leading to Anne Boleyn's execution are well documented. After failing to provide Henry VIII with a living male heir she fell out of favour. She also made an enemy of the powerful Thomas Cromwell, who had the

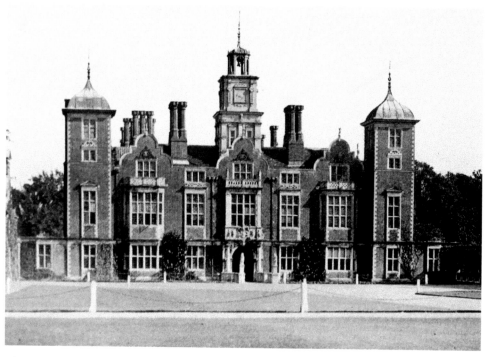

Blickling Hall c. 1900. (Charles Latham 1847–1912)

ear of the King and quickly plotted her downfall. It is generally accepted that her trial was a travesty and that the evidence against her was concocted. She was accused of plotting the King's death, committing adultery with five men including her brother, and practising witchcraft. All five of the accused men were found guilty and beheaded one after the other at Tower Hill on the morning of 17 May 1536. George Boleyn was the first to go under the axe. Anne was found guilty of treason and beheaded two days later by a French swordsman. Her father, Thomas Boleyn, was one of the jury members who unanimously found her guilty. Her uncle, Thomas Howard, 3rd Duke of Norfolk, was the Lord High Steward at the trial and delivered the guilty verdict. Anne proclaimed her innocence and by all accounts retained her dignity to the end. She died at 9 a.m. on 19 May 1536. The day after her execution the King became betrothed to his third wife, Jane Seymour, and the couple married on 30 May. After Anne's death, Henry VIII and Cromwell destroyed her portraits and letters, but Cromwell eventually found himself on the wrong side of the King and was beheaded on 28 July 1540. Henry and Anne's daughter, Elizabeth I, came to the throne in 1558 and ruled for over forty-four years.

Anne Boleyn's headless ghost is reputed to visit Blickling Hall in a phantom coach on the anniversary of her execution. Sightings have also been claimed inside the building and in the grounds. The property was bequeathed to the National Trust by its last private owner, Philip Kerr, 11th Marquess of Lothian, who died in December 1940. According to legend, Anne's ghost also visits Salle Church near Reepham, where some believe she was secretly buried under cover of darkness.

Henry VIII stayed overnight at East Barsham Manor.

During the reign of Henry VIII, Bishop's Lynn became King's Lynn when the Bishop of Norwich surrendered the town to the Crown. The much-feared monarch is believed to have been an overnight guest at East Barsham Manor, located 2½ miles north of Fakenham. He may have stayed there on several occasions, possibly with Anne Boleyn and another wife, Catherine of Aragon. The King is said to have walked barefoot from the house to the holy shrine at Walsingham around 2 miles away to ask forgiveness for his sins. East Barsham Manor was erected in the 1520s by Sir Henry Fermor and was rebuilt from a ruinous state in the 1920s and 1930s. Sir John Guinness was the owner for many years before he sold it in 2014 for a reported £2.75 million. The house is not open to the public.

Edmund, King of the East Angles

The ninth-century king long venerated as St Edmund is claimed by the people of Suffolk as their own, though he also has connections with Norfolk. In addition to Bury St Edmunds, the fallen king gave his name to the village of Caistor St Edmund near Norwich. St Edmund's Church stands next to the site of the Roman town Venta Icenorum. Already abandoned by his time, it is possible that Edmund's army or their Viking adversaries took shelter among the ruins. There are more churches named after St Edmund in Norfolk than in Suffolk, including those at Acle, Costessey, Downham Market, Emneth, Hunstanton and Fishergate in Norwich. At Fritton Church, which was formerly in Suffolk but is now part of Norfolk, a wall painting depicting Edmund's martyrdom has survived.

Edmund was probably born in AD 841 and was a young teenager when crowned King of the East Angles at Bures in Suffolk on Christmas Day 855 or 856. He is said to have been captured by the invading Danes in 869 or 870 and tied to a tree before being 'shot through with arrows'. His head was then cut off and tossed into a nearby wood. Abbo, a monk and abbot based at Fleury Abbey near Orleans in France, wrote of Edmund c. 986 and based his account on stories related by St Dunstan, who at that time was Archbishop of Canterbury. Ivar the Boneless and his brother Ubba allegedly carried out the foul deed. Much of the other information about Edmund comes from the quills of the twelfth-century historian and chronicler William of Malmesbury and the thirteenth-century writer Roger of Wendover.

According to Abbo, Edmund was killed at a place called Haegelisdun, traditionally associated with Hoxne in Suffolk but which some believe is actually Hellesdon near Norwich. Hellesdon was recorded as Hailesduna in the Domesday Book of 1086. In his *Saint Edmund and the Vikings 869–1066* (2018), author and historian Joseph C. W. Mason theorises that Edmund was killed in battle at Hellesdon and originally buried at St Edmund's Chapel in Lyng. His remains were later exhumed and reburied in Bury St Edmunds. The chapel in Lyng was part of a Benedictine convent which remained in use until 1176, when the nuns relocated to Thetford. The chapel bells were then supposedly thrown into the River Wensum, where their ghostly ringing can still be heard at night. Overgrown fragments of the chapel still exist in a field on the north side of Easthaugh Road in Lyng.

On the opposite side of the road, a wood known historically as the King's Grove contains the Great Stone of Lyng, a glacial erratic around 6 feet 6 inches (2 metres) long and 3 feet

Above: Remains of St Edmund's Chapel, Lyng. *Below*: The Great Stone of Lyng.

3 inches (1 metre) wide. It lies beside a public track and many weird and wonderful stories have been told about it. A local legend claims that it absorbed the blood of those who fell during a battle between Edmund's army and the Danes and still bleeds if pricked with a pin! The magical stone is also said to move by itself, to grow in size, and to have treasure buried beneath it. A local man is rumoured to have once tried to move the stone but his team of horses could not dislodge it. Some say that no birds sing in the vicinity and that spectral nuns occasionally cross the narrow road from the chapel ruins on their way to the stone. Lyng once had its own Guild of St Edmund and an annual fair on 20 November (St Edmund's day) was held until the late nineteenth century.

Edmund was England's first patron saint before Edward III replaced him with St George, but campaigns in 2006 and 2013 failed to have him reinstated. He is, however, still the patron saint of Kings, the Roman Catholic diocese of East Anglia – and pandemics! The latter is eerily appropriate at the time of writing during the global coronavirus crisis.

King John

King John granted Bishop's Lynn (now King's Lynn) a royal charter in 1204 and visited the town just before his death twelve years later. After spending a few days there, he left on 11 October 1216 with an entourage consisting of soldiers and servants plus animals. Legend tells us that they were carrying the crown jewels and other valuables when they

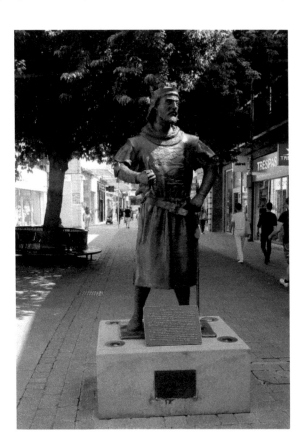

Statue of King John, King's Lynn.
(Photo © Jonathan Thacker,
CC-BY-SA/2.0, geograph.org.uk)

encountered strong tides the following day while trying to cross the Wash. Many men and beasts were supposedly lost, along with the treasure which was never recovered from the depths. King John, who may or may not have been leading his men at the time, survived this fate but soon succumbed to dysentery after eating lampreys either before leaving King's Lynn or on arrival at Wisbech Castle. He died at the age of forty-nine at Newark Castle in Lincolnshire on 18 or 19 October 1216.

A life-size cast-bronze statue of King John by Scottish sculptor Alan Beattie Herriot was unveiled in New Conduit Street by the Mayor of King's Lynn, David Whitty, on 12 October 2016, to mark the 800th anniversary of the incident in the Wash. The Stories of Lynn Museum in the Saturday Market Place houses the King John Cup, a priceless, highly ornate fourteenth-century drinking vessel.

The *Lynn News* reported in 2021 that an archaeologist from Yorkshire was '100 per cent confident' that he had found the location of the legendary missing treasure at 'an undisclosed site in Sutton Bridge'. He claimed to have unearthed artefacts and proclaimed that 'King John's baggage train and some of its prized possessions ... will soon see daylight again'.

Maharajah Duleep Singh

The story of the Last Maharajah of the Punjab is a poignant account of an exiled ruler who despite his best efforts never made it back to govern his own people. Sometimes referred to as the 'Stolen Maharajah', Duleep Singh was born in Lahore, the capital of the Sikh Empire, on 4 September 1838. His father was Ranjit Singh, known as the 'Lion of the Punjab'. Duleep Singh was destined to be the last in a long line of Maharajahs and inherited that title at the age of five. After the British annexed the Punjab in 1849, he was removed from power and held captive. He converted to Christianity in 1853 and was exiled to Britain the following year. On arrival in London he stayed at Claridge's Hotel before briefly living in Wimbledon and Roehampton. He was a popular guest of Queen Victoria and Prince Albert at Osborne House on the Isle of Wight.

In 1855, Duleep Singh moved to Castle Menzies in Perthshire, Scotland, before relocating to Elveden Hall in Suffolk, close to the boundary with Norfolk, in 1863. He then converted the 17,000-acre Elveden estate to a game park and became well known in the area, particularly in the South Norfolk market town of Thetford. An impressive life-size bronze statue of him on horseback was unveiled there by HRH the Prince of Wales in 1999.

Duleep Singh married Bamba Muller in 1864 and the couple had six children. She died at the age of thirty-nine on 18 September 1887. His second wife, Ada Douglas Wetherill, whom he married in 1889, bore him two more children. Singh reconverted to Sikhism in Aden in 1886 but was arrested there during an unsuccessful attempt to return to India. He then moved to Paris where he died on 22 October 1893. His body was returned to Britain and buried in Elveden churchyard.

One of Duleep Singh's sons, Prince Frederick Victor Duleep Singh (1868–1926), lived at Blo' Norton Hall in South Norfolk and presented the Ancient House to the town of Thetford for use as a museum. One of the Maharajah's daughters, Princess Sophia Alexandra Duleep Singh (1876–1948), became a leading figure in the women's suffrage movement. Her pioneering work was commemorated on the 'Votes for Women' stamp set issued by the Royal Mail in February 2018.

Maharajah Duleep
Singh's statue,
Thetford.

Modern Royal Connections

Sandringham House, the world-famous royal residence located in Northwest Norfolk, was originally constructed on the site of an earlier manor house in 1771. It was rebuilt in the mid-nineteenth century and again between 1870 and 1900. The house was acquired by Queen Victoria as a country retreat for the future Edward VII when he was Prince of Wales. His eldest son, Prince Albert Victor, the Duke of Clarence and Avondale, died at Sandringham House at the age of twenty-eight on 14 January 1892, from influenza and pneumonia probably caught during a New Year's Day shooting party. Also known as Prince Eddy, his death came shortly after becoming engaged to Princess Victoria Mary of Tech. She married his brother, the future George V, later becoming Queen Mary. George V inherited Sandringham House and estate in 1910 and died there on 20 January 1936. After the abdication of Edward VIII, his brother and the present Queen's father, George VI, purchased Sandringham. He also died there at the age of fifty-six on 6 February 1952, when Princess Elizabeth became Queen.

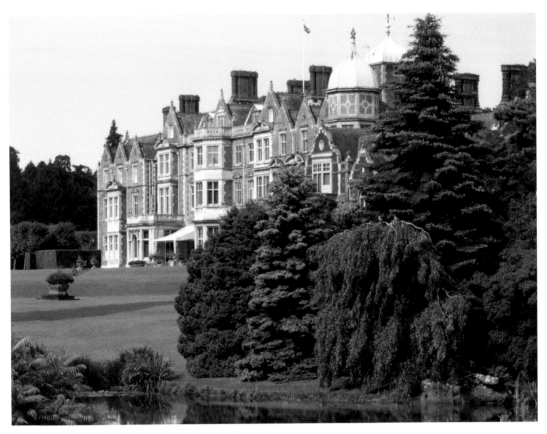

Sandringham House. (Photo © Paul Bryan, CC-BY-SA/2.0, geograph.org.uk)

Since then the house has been the private country residence of the Queen and the late Prince Philip, Duke of Edinburgh (10 June 1921–9 April 2021), and the place where they traditionally spent Christmas. George V gave the first Christmas radio broadcast live from Sandringham in 1932, his speech having been written by Rudyard Kipling. Exactly twenty-five years later his granddaughter, Elizabeth II, delivered the first televised Christmas broadcast from a study in the long library. Large crowds usually gather on Christmas Day to see the royal family attend the morning service at the Church of St Mary Magdalene. The tradition was broken in 2020 for the first time in thirty-two years when the Queen and the Duke of Edinburgh spent a quiet Christmas at Windsor Castle due to coronavirus restrictions. Sandringham was besieged by the world's media after the Duke's road traffic accident in January 2019. On 6 February 2022, the Queen spent the 70th anniversary of her accession to the throne at Wood Farm on the Sandringham estate.

Lady Diana Spencer, undoubtedly the best-known Norfolk person of the twentieth century, was born at Park House on the Sandringham Estate on 1 July 1961, and was baptised at the Church of St Mary Magdalene on 30 August that year. As HRH the Princess of Wales during her marriage to Prince Charles, Diana's life was obsessively scrutinised and documented. She rivalled the Queen as arguably the most famous woman in the

world before her tragic death following a car crash in Paris in August 1997. Her birthplace was acquired by the Leonard Cheshire Disability Trust in 1983 and later converted to a country house hotel for disabled people. The Queen, as Patron of the Trust, officially opened Park House Hotel on 31 July 1987. It was confirmed in November 2020 that the Trust would shortly be vacating the property.

Anmer Hall near Sandringham was presented to the Duke and Duchess of Cambridge by the Queen as a wedding gift. It was completely restored in 2013 at a reported cost of £1.5 million from private royal funds. At that time the Duke worked as a helicopter pilot for the East Anglian Air Ambulance. The house was built in the eighteenth century and was purchased by the Prince of Wales (future Edward VII) in 1898. The Duke and Duchess of Kent leased Anmer Hall as their country residence from 1972 to 1990 and it was then leased by other occupiers until 2013.

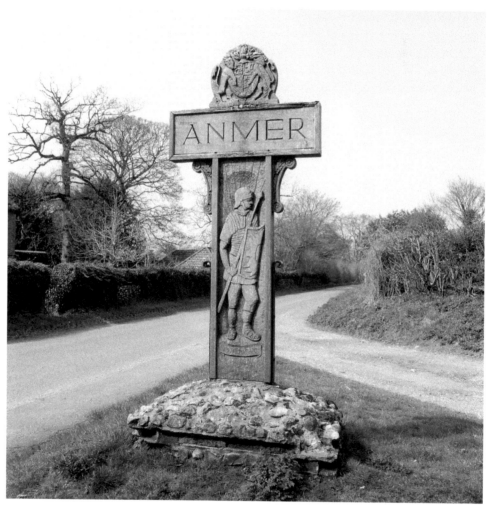

Anmer village sign. (Photo © Adrian S Pye, CC-BY-SA/2.0, geograph.org.uk)

4. Literary Locations and Inspirations

The *Black Beauty* Trail

Though Anna Sewell wrote just one published work it became a classic which ensured her immortality. *Black Beauty* has now sold over fifty million copies but the book's completion became a race against time as its author's health deteriorated. The story was written between 1871 and 1877 and the first edition was published by Jarrold & Son of Norwich in November 1877, when Anna Sewell was fifty-seven years old. It told the sometimes harrowing tale of an ill-treated horse from the perspective of the animal itself. Now regarded as a children's classic, it was aimed squarely at adults and was intended to highlight the widespread suffering of horses in Victorian England. Anna died just a few months after the book's publication and never knew the full extent of its success and subsequent impact on animal welfare, but she did live long enough to

Entrance to Dudwick Park, Buxton.

receive a number of letters from readers who were moved by the powerful story. Anna's own suffering infused her writing with the sometimes quite graphic realism that was necessary to make people take notice. She is said to have sold the copyright to the story for just £20.

Anna and her younger brother Philip enjoyed regular holidays with their maternal grandparents at Dudwick Cottage in Buxton, north of Norwich. Anna first developed her love of horses and learned to ride side-saddle in Dudwick Park, which provided inspiration for the fictional Birtwick Park in *Black Beauty* and now has a public bridle path passing through it. The park was owned by her Uncle John and Aunt Anne who resided in a mansion called Dudwick House, but this was demolished and replaced with a modern building bearing the same name in 1938. Dudwick Cottage stayed in the Sewell family until 1937 and still exists, though it has been extended. It can be viewed from the public path but is not open to the public. The park's entrance is located on Brook Street opposite the Black Lion public house.

Sewell Barn Theatre, located in the grounds of Sewell Park Academy on Constitution Hill, Norwich, was originally a stable for Philip Sewell's horse Black Bess or Bessie, which is believed to have been the main role model for *Black Beauty*. It is adjacent to Sewell Park, formally opened in 1909 on land that was previously part of his Clare House estate. A memorial horse trough (now a flower planter) and a commemorative plaque to Philip Sewell can be seen at the entrance.

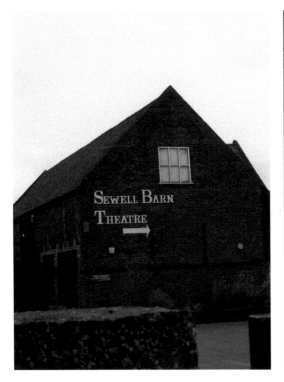

Left: Sewell Barn Theatre, Norwich. *Right*: Sewell Park, Norwich.

Conan Doyle and Sherlock Holmes

Two Sherlock Holmes stories are believed to have been directly inspired by Sir Arthur Conan Doyle's visits to North Norfolk. The fictional detective's creator became unwell with Typhoid (enteric fever) while in South Africa and on returning to England decided that a golfing break by the sea would do him good. In the summer of 1901, Doyle and his friend Bertram Fletcher Robinson, a journalist and author, stayed at Cromer's Royal Links Hotel, which mysteriously burned down while unoccupied in 1949. Doyle's presence in the town created quite a stir and was widely reported in the local press. It was here that he and his companion learned of the legend of Black Shuck, a supernatural spirit that is said to take the form of a giant black dog. Stories of encounters with the mythical beast go back centuries and are particularly prevalent in North Norfolk. Doyle was invited to dinner at Cromer Hall by owner Benjamin Cabbell, who is believed to have told him of another black dog legend specific to the Cabbell family.

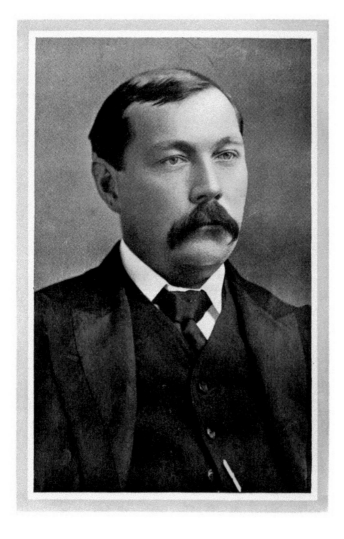

Portrait of Sir Arthur Conan Doyle. (Wellcome Collection CC BY-4.0)

The story goes that Benjamin Cabbell's ancestor, Squire Richard Cabbell III, came to a sticky end after he became convinced that his wife had been unfaithful. He pursued her across the moors and stabbed her to death. At this moment her large pet dog clamped its jaws around Cabbell's throat and he too was killed. The creature then went feral and its ghost – much larger and more monstrous than in life – later terrorised the local area. The horrific apparition then proceeded to appear to successive generations of the Cabbell family. The known facts are that Richard Cabbell, Lord of Brook Hall and Buckfastleigh on the edge of Dartmoor, died on 5 July 1677 and was interred in the family mausoleum at Holy Trinity Church. His reputation as a cruel and immoral man has survived and been added to down the centuries, though there appears to be no evidence that he murdered his wife. In Sir Arthur Conan Doyle's *The Hound of the Baskervilles*, written in 1901 after his holiday in Cromer, Hugo Baskerville 'hunted an innocent maiden over the moor by night'.

Cromer Hall, built in 1829 and extended in 1875, is still the private residence of the Cabbell-Manners family and is not open to the public. It is located to the south of Cromer on the road to Felbrigg and can be viewed from Hall Road. Doyle never publically acknowledged Cromer as a source of inspiration but his description of Baskerville Hall closely matches the exterior of Cromer Hall. It is also claimed that Baskerville was the name of the coachman who conveyed the author to Cromer Hall for dinner. In a letter written in 1907, Doyle stated that 'my story was really based on nothing save a remark of my friend Fletcher Robinson's that there was a legend about a dog on the moor connected with some old family'.

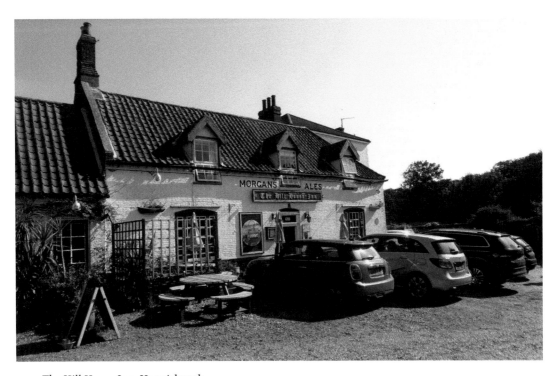

The Hill House Inn, Happisburgh.

Sir Arthur Conan Doyle, who passed away at the age of seventy-one in 1930, visited Norfolk again in 1903 and stayed at the Hill House Hotel in Happisburgh. It was here that he got the idea for another Sherlock Holmes story, *The Adventure of the Dancing Men*. In the book, Holmes has to decipher a code based on drawings of dancing figures in order to solve the case – which, of course, he does! It is said that Gilbert Cubitt, son of the landlord, came up with a unique signature using similar figures and showed it to Doyle. Unlike *The Hound of the Baskerville*s, the story is set in Norfolk and features a character named Hilton Cubitt. The fictional Cubitt lives at a place called Ridling Thorpe, which is a combination of the names of two actual local villages, Ridlington and Edingthorpe.

The Hill House still exists and is now a public house rather than a hotel. The front wall carries a blue plaque recording the author's visit.

Charles Dickens and David Copperfield

Another best-selling author, Charles Dickens (1812–70), found inspiration for one of his books on a visit to Great Yarmouth. He stayed at the Royal Hotel on Marine Parade with two friends in January 1849, and a plaque on the front records his visit. He also went to the Norfolk Naval Pillar, erected in honour of Lord Nelson, where he met custodian James Sharman who took part in the Battle of Trafalgar. Dickens is believed to have based the

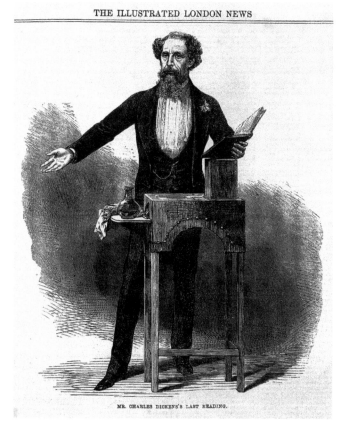

Charles Dickens giving the last public reading of his works. (Wellcome Collection CC BY-4.0)

The Royal Hotel, Great Yarmouth.

character of Ham Peggotty in his novel *David Copperfield* on Sharman. Clara Peggotty's house in the book was an upturned boat on the beach 'with an iron funnel sticking out of it as a chimney', and she proclaimed Great Yarmouth to be 'the finest place in the universe'. Dickens walked along the coastline to Lowestoft and saw a road sign to the village of Blundeston, which he changed very slightly to Blundestone for the birthplace of the book's title character. Whether Dickens actually set foot in Blundeston, located just over the border in Suffolk, is uncertain, but David Copperfield is depicted on the village sign. Dickens is thought to have partly based the title character on himself.

The author visited Norwich on 7 January 1849 before travelling to the coast, and was reportedly one of up to 20,000 people who witnessed the public hanging of convicted murderer James Rush at Norwich Castle on 21 April 1849. Over the years, Dickens visited Norfolk and Suffolk on several other occasions.

Daniel Defoe and Robinson Crusoe

Over a century before Dickens, prolific writer Daniel Defoe (*c.* 1660–1731) also visited Great Yarmouth and found it very much to his liking. He waxed lyrical about the town in his mammoth *A Tour thro' the Whole Island of Great Britain*, published in three volumes between 1724 and 1727. The port, at that time one of England's busiest, also provided

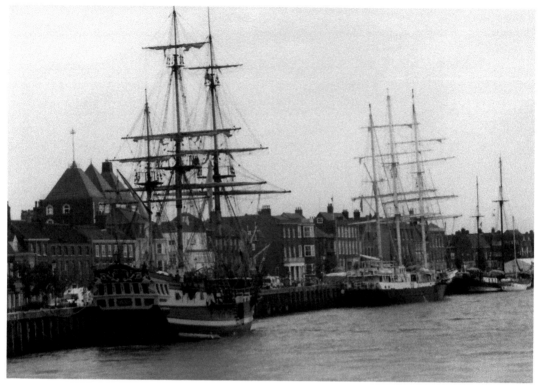

Tall ships in Great Yarmouth, 2004.

inspiration for his epic novel *Robinson Crusoe* (1719). Early in the book, the title character is caught in a storm just off Great Yarmouth and is shipwrecked at nearby Winterton. He is then taken back to the town before setting out again on a fictitious voyage and eventually spending twenty-eight years marooned on a desert island.

The story was probably partly inspired by the real-life adventures of Alexander Selkirk (1676–1721), a Royal Navy officer from Fife in Scotland who survived for over four years on an uninhabited island before finally being rescued.

I Walked by Night

A book intriguingly titled *I Walked by Night* was first published in 1935 as the autobiography of an anonymous author known only as the 'King of the Norfolk Poachers'. It was edited by Lilias Rider Haggard, youngest daughter of best-selling author Sir Henry Rider Haggard. The book told the story of a countryman who operated outside the law for much of his life and was no stranger to a prison cell.

The identity of the mysterious writer was finally revealed long after his death as Frederick Rolfe, who was born in Pentney, Norfolk, in 1862. In his book he claimed that he was imprisoned in Norwich Castle (now a fine museum) and made to walk the treadmill when 'little more than a child'. Records show that he was first sentenced to two weeks' hard labour there for poaching rabbits in November 1882, when he was twenty years

Norwich Castle.

old. Rolfe's last spell behind bars was around forty-five years later. He was employed as a gamekeeper on the West Bilney Estate for around three years in the 1890s before being dismissed.

Rolfe relocated to Bungay, just over the border in Suffolk, during the First World War and continued his nefarious nocturnal practices while working by day as a rat and mole catcher. For the last fourteen years of his life he lodged at the home of Mrs Jessie Redgrave in Nethergate Street. Rolfe died by his own hand on 23 March 1938, when a policeman discovered his lifeless body hanging from a wire snare attached to a beam in a nearby outbuilding. The snare was one of a collection that he used to trap wild animals. He was buried in an unmarked grave in Bungay cemetery.

Though it may contain exaggerated or inaccurate information, *I Walked by Night* is a fascinating read and over the years has become something of a local cult classic. It is written in the Norfolk dialect and is still in print nearly ninety years after it was first published.

Swallows and Amazons

Swallows and Amazons, the first in a twelve-part series of children's books written by Arthur Ransome (1884–1967), was first published in 1930. Along with another four books

The Swan Inn, Horning.

it is set in the Lake District, but the Norfolk Broads provided the backdrop for two of the other stories. *Coot Club*, published in 1934 and the fifth book in the series, is partly set around the village of Horning and its various waterways and also includes trips to Breydon Water, Great Yarmouth and Beccles. It features Dick and Dorothea Callam, who visit the county to stay with a family friend, while the title refers to a group of local children who try to protect nesting birds (the coot being a species of water bird very prevalent on the Broads) from inconsiderate boaters and egg collectors.

The Big Six, published in 1940, is the ninth book in the series and reunites the Callam children with friends they made on their earlier visit. They join forces to investigate who is behind incidents of boats being cast adrift and finally unmask the culprits.

According to Roger Wardale's book *Arthur Ransome on the Broads* (Amberley Publishing, 2013), the author's inspiration for the two Norfolk-based books came from eight boating holidays with his wife on the man-made waterways during the 1930s.

Thomas the Tank Engine and Friends

The Reverend Wilbert Awdry (1911–97), creator of *Thomas the Tank Engine and Friends*, lived and wrote at the Old Vicarage in Emneth in West Norfolk from 1953 to 1965, when

he was vicar of St Edmund's Church in the village. The characters were invented during the 1940s for the entertainment of Awdry's son Christopher when he was suffering from measles. As many as eleven books in the series were written during his time in Emneth. The vicar, who unsurprisingly was a railway enthusiast, spent much of his leisure time in his loft creating and running a large model railway.

The Awdry family commissioned a stained-glass window at St Edmund's Church in 2003 with a depiction of Thomas the Tank Engine. It was dedicated the following year. A blue plaque was placed on the Old Vicarage in 2011 and the building was offered for sale at £895,000 in February 2020.

Emneth village sign and church. (Photo © Adrian S Pye, CC-BY-SA/2.0, geograph.org.uk)

5. Film and Television Connections

Film and TV Personalities with Norfolk Links

Sir John Mills CBE (1908–2005) was born at Watts Naval School in North Elmham near Fakenham, where his father taught. In late 1920 he became a student at Norwich High School for Boys in Upper St Giles Street. The building is now used as an office and a blue plaque records Mills' sojourn there. He briefly returned in 2000 with his actress daughter Juliet Mills, and was photographed looking at his initials that he carved into the brickwork eight decades earlier. His other daughter, Hayley Mills, is another famous actress and his son, Jonathan, is a film director. Sir John Mills, who was rejected by Norwich City FC because he was considered too small, acted in more than 200 films.

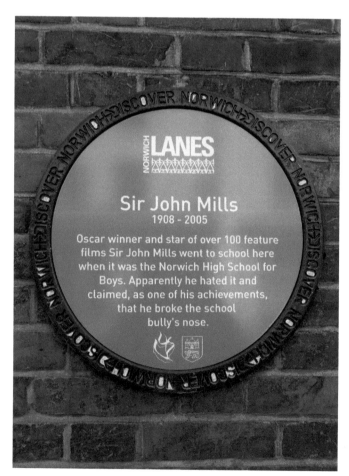

Sir John Mills' plaque, Norwich.

Actress Olivia Colman was born in Norwich and privately educated at Norwich High School for Girls and Gresham's School, Holt. She gained 2st 7lb in weight to play Queen Anne in the successful movie *The Favourite* (2018), for which she won BAFTA and Golden Globe awards. In 2019, she began playing Queen Elizabeth II in the Netflix drama *The Crown*. She also took part in an edition of *Who Do You Think You Are?* (BBC TV, 2018), during which she stated that wherever she lives she will always regard Norfolk as home.

Another actress, Ruth Madoc, best known as Gladys Pugh in *Hi-de-Hi!* and Daffyd Thomas's mother in the second series of *Little Britain* (both BBC TV), was surprisingly also born in Norwich but moved to Wales as a child.

Sir John Hurt, one of Britain's most versatile actors, spent much of his later life in Norfolk. His most memorable film roles include Kane in *Alien* (1979), John Merrick in *The Elephant Man* (1980) and Winston Smith in George Orwell's *1984*. He was knighted in 2015 for services to drama. John Hurt became the first chancellor of the Norwich University of the Arts in 2012 and was a supporter of Norwich City FC. He passed away due to pancreatic cancer at his home near Cromer on 25 January 2017, just three days after his seventy-seventh birthday.

Roger Lloyd Pack (1944–2014), best known for playing Trigger in *Only Fools and Horses* and Owen Newitt in *The Vicar of Dibley* (BBC TV), also sadly succumbed to pancreatic cancer. For forty years he divided his time between London and Norfolk and had a home at Hindolveston near Fakenham. He supported Sheringham Little Theatre and was patron of Creative Arts East. One of his last film roles was as Norman in the movie *In Love with Alma Cogan*, which was filmed in Norfolk.

Actor and writer Stephen Fry was born in London but moved to Norfolk with his family as a child. He lived at Booton House in the village of the same name near Reepham and now has a home at West Bilney on the A47 between Swaffham and King's Lynn. He was a director of his beloved Norwich City FC from August 2012 till January 2016, when he became a 'Norwich City Ambassador'. Fry played the role of Oscar Wilde in the film *Wilde* (1997) and appeared in various series of *Blackadder* (BBC TV) between 1986 and 1999. He was cast as Peter Kingdom in the ITV series *Kingdom* (see Other Locations section of this chapter).

Birmingham-born actor Martin Shaw lives in Hingham, a small Norfolk market town famous for its scarecrow festivals. He made his television breakthrough as Ray Doyle in *The Professionals*, and has also starred in *Judge Roy Deed*, *The Chief* and *Inspector George Gently*. He was once spotted in Hingham by excited clue hunter Becky Betts, during a 'live' broadcast of BBC Radio Norfolk's *Treasure Quest* Sunday morning show. Martin Shaw is patron of Hillside Animal Sanctuary in Frettenham.

Actress Liza Goddard was born in Staffordshire but has lived near Dereham in mid-Norfolk for a number of years. Formerly married to *Dr Who* actor Colin Baker and singer Alvin Stardust, she was a founding member of the Norfolk-based Hawk and Owl Trust.

Well-known television cook Delia Smith was born in Surrey but has long been associated with Norwich City Football Club. Along with her husband, Michael Wynn-Jones, she is joint majority shareholder of the club. Her television career began in the early 1970s when she became a regular on the regional BBC teatime programme *Look East*. She was given her own cookery show, *Family Fare*, in 1973, but retired from television work in 2013. Delia is also famous for baking the cake that graced the front cover of the Rolling Stones album *Let It Bleed*.

A resting Hingham 'resident' in 2012.

Carrow Road, home of Norwich City FC.

Television presenter Caroline Flack was raised in Thetford and Wretham and attended Great Hockham Primary School and Wayland High School. She won the twelfth series of the BBC's *Strictly Come Dancing* in 2014 and presented *Love Island* (ITV) from 2015 till 2019. Her autobiography, *Storm in a C Cup*, was first published in 2015 and reissued following her sad death at the age of forty on 15 February 2020.

James Bond Locations and Other Connections

Norfolk unexpectedly has several links with the James Bond franchise. One of the unlikely 'stars' of *You Only Live Twice* (1967) was a Wallis WA-116 autogyro named *Little Nellie*, a flying machine similar in appearance to a small helicopter but with an unpowered free-spinning rotor. It was developed and flown by Wing Commander Ken Wallis, who was actor Sean Connery's stunt double in scenes where Bond's autogyro was involved in aerial battles with helicopters. After retiring from the Royal Air Force in 1964, he moved to Norfolk with his wife Peggy and settled at Reymerston near Dereham. Wing Commander Wallis received an MBE in 1996 and was awarded a campaign medal shortly before his death at the age of ninety-seven on 1 September 2013.

Wing Commander Ken Wallis and *Little Nellie*, Norwich Rugby Club, 2009.

Another mechanical marvel that made a huge contribution to a Bond film was the white Lotus Esprit S1 in *The Spy Who Loved Me* (1977). Several cars were used in the film, including a semi-functioning submarine version which reportedly cost around $100,000 to develop and build. The sports car manufacturer, founded by Colin Chapman and based at Hethel near Norwich, also supplied two Lotus Esprit S3 Turbo models for another Bond movie, *For Your Eyes Only* (1981).

Repps Level Mill, one of the Broads' numerous redundant windpumps, was converted to a residence around 1970. Its main claim to fame is that Sir Roger Moore (14 October 1927–23 May 2017), who played 007 in seven films between 1973 and 1985, was a former owner. The Moore 'wow' factor has not been lost on the current owners, who renamed the property 'Bond Island Windmill' after alterations and repairs in late 2020. Pictures from classic Bond films adorn some of the interior walls and a 'Shaken, not stirred' sign hangs in the outside bar area. The mill is located beside the river Thurne around half-a-mile from Potter Heigham Bridge and is available for hire as a unique holiday retreat.

The surname of Bond's great adversary, Ernst Stavro Blofeld, portrayed on screen by Donald Pleasence, is said to have been 'borrowed' from Norfolk farmer Tom Blofeld, who attended Eton College with author and Bond creator Ian Fleming. Tom was the father

'Bond Island Windmill' was once owned by Sir Roger Moore.

of famous former BBC cricket commentator Henry Blofeld, who was born and raised in Hoveton near Norwich.

A North Korean paddy field in the 2002 movie *Die Another Day* was actually farmland at Burnham Deepdale in North Norfolk. Filming also took place at RAF Marham and the film starred Pierce Brosnan as Bond.

Don't Panic! *Dad's Army* Connections

The very successful BBC comedy series *Dad's Army* was mainly filmed in Norfolk and Suffolk, particularly in and around the town of Thetford. First shown in 1968, the programme ran until 1977 and became something of a British television institution. Arthur Lowe starred as Captain George Mainwaring with John Le Mesurier as Sergeant Arthur Wilson, Clive Dunn as Lance Corporal Jack Jones, John Laurie as Private James Frazer, Arnold Ridley as Private Charles Godfrey and Ian Lavender as 'stupid boy' Private Frank Pike.

Many of the outdoor scenes were filmed at the Stanford Training Area (STANTA) near Thetford. The town's Guildhall became the fictional Walmington-on-Sea Town Hall and had a leading role in the 'Time On My Hands' episode (1972), when a German pilot was left hanging by his parachute from the hands of the town hall clock. The Guildhall also featured in 'The Captain's Car' episode in 1974. Other Thetford locations used over the years include the Palace Cinema and Nether Row flint cottages. In addition to the Thetford area, filming also took place across the county in Bressingham, Great Yarmouth, Oxburgh Hall and various other locations. An early episode, 'Sons of the Sea', was filmed on the Norfolk Broads. Weybourne Railway Station in North Norfolk was used in 'The Royal Train' episode in 1973.

The Dad's Army Museum, which opened in December 2007 in a former fire station in Cage Lane, Thetford, behind the Guildhall, purchased the original 1935 Ford BB 'Jones the Butcher' van for a reported £63,100 at auction five years later. After being restored to its former glory the van was loaned to the Charles Burrell Museum in Minstergate, Thetford.

A seated statue of Captain Mainwaring was unveiled by the riverside in Thetford in June 2010, with space for fans to pose alongside him for 'selfies'. The Bell Hotel in King Street, where the cast often stayed during filming, is still open. Sadly, the 500-year-old Anchor Hotel, used mainly by the crew, fell into disrepair and was controversially demolished in 2012. The opening scene of the very first episode, 'The Man of the Hour' (1968), was filmed there. Bressingham Steam Museum near Diss supplied a number of vintage vehicles for *Dad's Army* and later hosted special open days attended by surviving cast members. The museum still has a collection of vehicles used in the show and finally got its own television series in 2020, when *Inside the Steam Train Museum* (Channel 5) was first transmitted.

Other David Croft productions, *'Allo 'Allo* and *You Rang My Lord?* (BBC TV), also utilised Norfolk locations. Both programmes used Lynford Hall near Mundford, which also appeared in some *Dad's Army* episodes. In *'Allo 'Allo*, which ran from 1982 to 1992, it featured as Rene's cafe in occupied wartime France. In addition, *'Allo 'Allo* was filmed on location at Beeston Church, Denver Windmill, Thetford Forest and Briston.

Capt. Mainwaring's statue, Thetford.

Norwich Film and TV Locations

Norwich has appeared numerous times in films and on television. Norwich Cathedral is one of the county's most filmed buildings and a temporary medieval castle was constructed within its interior for the fairy-tale adventure *Jack the Giant Slayer* in 2013. The cast included Ian McShane, Ewan McGregor and Bill Nighy.

The building again featured prominently in *Tulip Fever* (2017), written by Tom Stoppard and starring Alicia Vikander and Dame Judi Dench. The film was set in seventeenth-century Amsterdam during the Tulip Wars and much of the filming took place in the cloisters. *Dean Spanley* (2008), a Victorian drama starring Peter O'Toole and Sam Neill, also used the cathedral cloisters plus Elm Hill. Norwich Cathedral, Tombland, The Maid's Head Hotel and Thorpe Station all appeared in *The Go Between* (1970), together with other locations across Norfolk. The movie starred Julie Christie and Alan Bates.

Elm Hill, one of the city's most famous and historic streets, is a popular film location. The successful 2007 fantasy *Stardust*, starring Clare Danes, Robert de Niro, Peter O'Toole, Michelle Pfeiffer and Sienna Miller, used the street to good effect with amazing props and computer-generated imagery (CGI). The Briton's Arms, which may date back to the fourteenth century, briefly became 'The Slaughtered Prince' complete with a temporary thatched awning. After filming was completed the street returned to normal and the building went back to being a coffee house and restaurant.

Elm Hill was again transformed in June 2019 for the musical fantasy *Jingle Jangle: A Christmas Journey*. Set in fictional Cobbletown during the Victorian era, it starred Forest Whittaker as a toymaker and inventor named Jeronicus. Elm Hill and other nearby roads were closed for ten days during filming, which saw fake snow applied to window sills and lamps, and imitation meat hanging from the exterior of a bogus butcher's shop. It was first shown on Netflix and in some theatres in November 2020.

The Beethoven sketch for the typically surreal Monty Python film *And Now for Something Completely Different* (1971) was shot in Elm Hill. Several of the links between sketches, featuring John Cleese sitting at a desk, were filmed near Norwich Castle.

Although mainly shot in Suffolk, *Lovejoy* (BBC TV, 1986–94), starring Ian McShane as the eponymous antiques dealer, made the odd trip across the border into Norfolk. Elm Hill was a location in 'The Real Thing' episode in series one.

The successful movie *Fighting with My Family* (2019) was based on the true story of Norwich-born Saraya-Jade Bevis, who as wrestler Paige became a star of WWE in America. Written and directed by Stephen Merchant and featuring American wrestler-turned-actor Dwayne 'The Rock' Johnson, the film was mainly shot in central Norwich and on Mousehold Heath in front of the former Britannia Barracks overlooking the city. It was inspired by the 2012 Channel 4 documentary *The Wrestlers: Fighting with My Family*, which Johnson discovered while flicking through television channels in a hotel room.

The fictional radio DJ and television presenter Alan Partridge, played by Steve Coogan, has long been associated with Norwich. He first arrived on the small screen in the 1990s and various locations have appeared over the years including Norwich Cathedral and the railway station. The feature film *Alan Partridge: Alpha Papa* was also partly filmed in the city including Dereham Road and outside City Hall on St Peter's Street. Coogan attended

Norwich Cathedral as seen from the cloisters. (Courtesy of Norwich Cathedral)

Elm Hill, Norwich.

The former Britannia Barracks, Norwich.

the world premier at the Hollywood Cinema in Anglia Square, Norwich, on 24 July 2013, in the guise of Partridge.

Norwich City Hall also appeared in the film *Wilt* (1989), along with other nearby locations. It starred Griff Rhys Jones, Alison Steadman and Mel Smith, and was partly filmed in Horning, Ranworth and Thetford.

The film *45 Years* (2015), with Charlotte Rampling and Tom Courtenay, made extensive use of Norwich city centre including shots of the Royal Arcade, the Assembly Rooms, St Benedict's Street, London Street and Jarrold department store.

The long-running series *Tales of the Unexpected* (Anglia TV 1979–88) was filmed at many Norwich locations including the Norwich Union (now Aviva) Marble Hall, Bowthorpe Cemetery, Princes Street, Upper St Giles and the former Anglia TV studios in Magdalen Street (now Epic Studios). Roald Dahl wrote some of the stories and introduced each one. Other series locations included Aylsham, North Walsham, Thetford Forest, Oxburgh Hall and Hunstanton Beach, which substituted for Jamaica!

Shooting locations for the ITV science-fiction drama *The Uninvited* (1997), with Leslie Grantham and Douglas Hodge, included Norwich Magistrates' Court, Orford Place, the EDP offices, the Golden Star public house and the University of East Anglia. The UEA's Sainsbury Centre of Visual Art was used as the Upstate New York headquarters of Marvel's Avengers in the movies *Age of Ultron* (2015), *Ant-Man* (2015) and *Spiderman: Homecoming* (2017).

'RedBall' at Pull's Ferry, Norwich, May 2010.

Channel 4's documentary series *Britain's Most Historic Towns* named Norwich as the place that best represents the Tudor period. The show's presenter, Professor Alice Roberts, visited many locations around the city including Norwich Cathedral, Elm Hill, Mousehold Heath, Bishop Bridge and the Lollard's Pit public house. She morris danced through the city's streets to the historic Guildhall with comedian Tim Fitzhigham and others, re-enacting the climax of Will Kemp's famous morris dance from London to Norwich in 1600. With a cry of 'into the stinking Wensum I go!', Professor Roberts also underwent the indignity of being labelled a 'scold' before being ducked in the water at Pull's Ferry. The programme was first transmitted on 28 April 2018. Pull's Ferry was one of several locations to host the 15-foot (4.57-metre) 'RedBall' portable art installation during the Norfolk and Norwich Festival in May 2010, which attracted widespread media coverage.

The Norfolk Broads

The Norfolk Broads have appeared on screen many times, perhaps most surprisingly substituting for Vietnamese paddy fields in the Stanley Kubrick-directed movie *Full Metal Jacket* (1987). They are seen from the air as a US Army helicopter appears to fire its guns at the Norfolk countryside.

Ludham Bridge Stores once appeared in *Eastenders*.

Also unexpectedly, some scenes for the soap opera *Eastenders* (BBC TV) were filmed in deepest Norfolk in the summer of 1998. Various locations including Ludham Bridge Stores and Horning were visited by a group of the show's younger characters who briefly swapped fictional Walford for a boating holiday on the Broads. Predictably, the storyline was controversial in its depiction of sex, crime and bad behaviour on the hallowed waterways!

An episode of *Great Canal Journeys* (Channel 4) was filmed on the Broads in 2017, when husband and wife actors Timothy West and Prunella Scales explored the area on a vintage 1938 cruiser. They moored the *Lady Christina* beside the unusual Hoveton Marshes Mill, which was converted to residential accommodation in the early 1930s by local author and artist Drew Miller. He added a glazed top storey with a gallery and this became his studio. West and Scales also stopped at St Benet's Abbey ruins, Horning, Reedham Ferry, How Hill and other locations.

They also took a trip on the wherry *Albion*, as did Paul Merton and his wife Suki Webster in an episode of *Motorhoming with Merton and Webster* (Channel 5). Not to be outdone, comedian Susan Calman hitched a ride on the same vessel in her *Grand Day Out on the Norfolk Broads* (Channel 5). While in the county she also visited Cromer, Cley

Hoveton Marshes Mill and *Lady Christina*. (Photo © David Middleton)

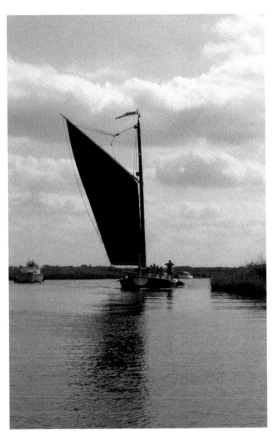
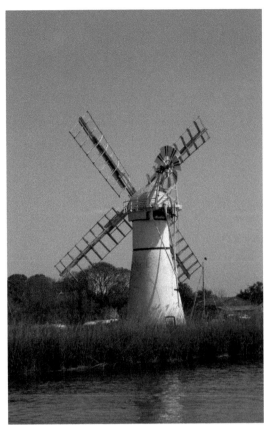

Left: The wherry *Albion*. *Right*: Thurne Mill.

Marshes and Bircham Windmill. Fellow comedians Bob Mortimer and Paul Whitehouse visited the Broads as part of their *Gone Fishing* series (BBC TV). All three programmes were first transmitted in autumn 2021.

Thurne Mill, one of Norfolk's most famous windpumps, appeared in the aforementioned broadcasts and was also featured on *Countryfile* (BBC TV) on 10 February 2019. The show's Matt Baker helped repaint the mill in June 2018. Some years earlier, it was seen with sails turning on a travel programme presented by David Dimbleby.

St Peter and St Paul's Church in Runham, situated between Acle and Great Yarmouth, appeared in the 1974 Christmas Special of the popular BBC comedy series *Some Mothers Do 'ave 'em*. It featured Frank Spencer, played by Michael Crawford, crashing through the church roof while dressed as an angel before being airlifted away by helicopter! A hole was deliberately made in the roof but was repaired after filming was completed. A copy of the BBC contract was once displayed inside the church, which was already disused at that time and was derelict for many years afterwards. It has been extensively restored during the present century and is open to the public during daylight hours.

Runham Church.

Great Yarmouth Area

Delving way back into the mists of cinematic time, the silent film *The Rolling Road* (1926), starring Carlyle Blackwell and Flora Le Breton, was filmed in Great Yarmouth.

An episode of the long-running BBC TV comedy *Keeping Up Appearances*, with Patricia Routledge and Clive Swift, was filmed at Great Yarmouth Pleasure Beach. Part of the music video for *House of Fun* by the group Madness was shot at the same location on 7 March 1982. It featured the 'nutty boys' riding on the park's vintage 1930s scenic railway (roller coaster).

Just over the River Yare in Gorleston, the Pier Hotel played a prominent role in the film *Yesterday* (2019), written by Richard Curtis and directed by Danny Boyle, who stated that Gorleston Beach was 'one of the great secrets of England'. 6,000 extras cheered enthusiastically on the beach as fictional pop superstar Jack Malik (played by Himesh Patel) performed at the Pier Hotel. Following a collision with a bus during a brief worldwide power cut, struggling singer-songwriter Malik seemingly becomes the only person on earth who remembers The Beatles. He then passes off their songs as his own and becomes the world's biggest star. The film also starred Lily James as Malik's manager and love interest Ellie Appleton, and Sanjeev Bhasker and Meera Syal as his parents

Great Yarmouth Pleasure Beach roller coaster.

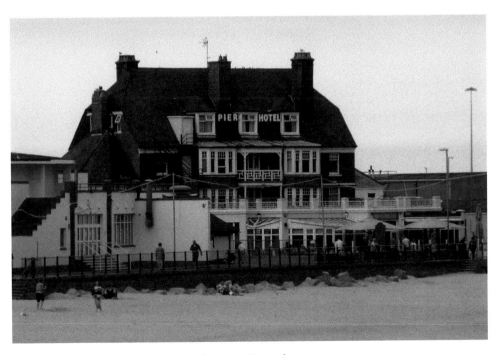

The Pier Hotel, Gorleston, appeared in the movie *Yesterday*.

Jed and Sheila Malik. Real-life Suffolk-based superstar Ed Sheeran and actor and talk show host James Corden appeared as themselves.

The Chief, an Anglia TV police drama which originally ran from 1990 till 1995, was partly filmed in Great Yarmouth and Gorleston. It starred Tim Pigott-Smith (series one to three) and Martin Shaw (series three to five). Great Yarmouth locations also pop up in the films *Cuckoo* (2009), starring Richard E. Grant, and *The Scouting Book for Boys* (2009). The Oscar-winning film *Julia* (1977) was partly filmed at Winterton-on-Sea, around 5 miles north of Great Yarmouth. The small coastal village stood in for Cape Cod and the movie starred Jane Fonda, Vanessa Redgrave and Jason Robards.

North Norfolk

Happisburgh Lighthouse, the oldest working lighthouse in East Anglia and the only one in Britain to be independently run, was famously painted by the *Challenge Anneka* (BBC TV) team. An edition of the programme, presented by Anneka Rice, saw the entire exterior and interior of the lighthouse repainted on 30 and 31 August 1990, before the crew moved on to their next challenge. Newspaper headlines in 1997 screamed that 'the wrong type of paint' was used on the exterior and claimed that the lighthouse was in desperate need of another repaint at an estimated cost of £30,000. Since then, the building has been repainted on two occasions using an expensive mineral-based paint. Happisburgh Lighthouse also appeared in *AfterDeath*, a horror film released in 2015, and in a music video for Ellie Goulding's song *The Writer* in 2010.

Left: Happisburgh Lighthouse. *Right*: Happisburgh Church.

Also in Happisburgh, poet Sir John Betjeman visited St Mary's Church while making *A Passion for Churches* (BBC TV) in 1974. The church was used in *A Warning to the Curious* (BBC TV, 1972), an adaptation of M. R. James' ghost story. The churchyard contains the remains of numerous shipwrecked sailors who perished during the eighteenth and nineteenth centuries. Another adaptation of a book by the same author, *Whistle and I'll Come to You* (BBC TV, 1968), was partly filmed in the dunes at Waxham near Sea Palling.

Devices and Desires was filmed mainly in North Norfolk for an Anglia TV six-part miniseries in 1991. Written by P. D. James and set on a fictional Norfolk headland named Larksoken, it starred Roy Marsden as Commander Adam Dalgliesh and Susannah York as Meg Dennison. Her home in the series was a house at Eccles-on-Sea and other locations included Holkham Beach, Salthouse, Wells, Great Yarmouth and Norwich. Cley Windmill played the part of Larksoken Mill, which Dalgliesh inherits from an aunt. This puts him on the trail of a serial killer called 'The Whistler'.

Cley Windmill has also featured in other film and television productions. It appeared in the films *Conspirator* (MGM, 1949), starring Elizabeth Taylor and Robert Taylor, and *Conflict of Wings* (1954), which also featured locations in Wells, West Raynham and Ludham. TV appearances include *The Ruth Rendell Mysteries* (ITV), a David Bellamy natural history series, and *Kingdom* (ITV) starring Stephen Fry. For several years the mill

Cley Windmill.

was seen in a BBC TV continuity link with a hot-air balloon passing overhead and its sails apparently turning, though this may have involved electronic trickery as the cap and sails are said to be permanently fixed in one position. Cley Mill also has connections with musician James Blunt and his family (*see* final chapter), and Cley marshes were featured in the film *The Duchess* (2008), starring Keira Knightley.

Cromer Pier was the unlikely setting for a shoot-out in the film *Alan Partridge: Alpha Papa* (2013), which also included Sheringham and other Norfolk locations. The lifeboat house at Cromer and locations at Wiveton near Blakeney were featured in the 2011 movie *In Love with Alma Cogan*, starring Keith Barron, Niamh Cussack and Roger Lloyd Pack. *September Song* (ITV, 1993–95) was also filmed in Cromer and starred Russ Abbot and Michael Williams. Cromer, Overstrand, Weybourne and Trunch were key locations for the drama *Poppyland* (BBC TV, 1985), starring Alan Howard, Phoebe Nichols and John McEnery. It was based on the true story of how Clement Scott, a nineteenth-century theatre critic, put North Norfolk on the tourist map.

The film *Chick Lit* (2015) was mainly filmed in North Norfolk in the summer of 2014, including locations in Blakeney, Cromer, Sheringham, Holt, Morston and Hunworth. The cast included Sir John Hurt, Dame Eileen Atkins and Caroline Catz.

Cromer Pier.

The picturesque village of Heydon near Reepham is a favourite location for film crews. *The Go Between* (1970), which also included Melton Constable Hall and other Norfolk places, was partly shot at a cottage on Heydon village green. The same location plus the nearby church wall were used in a *Monty Python's Flying Circus* (BBC TV) sketch called 'The Idiot in Society', featuring John Cleese wearing a traditional countryman's smock. The village was also seen in the Anglia TV programmes *Weavers Green* (1966) and *Backs to the Land* (1977–78). Heydon became the fictional village of Arcady in *Love on a Branch Line* (BBC TV, 1994), which also featured Oxburgh Hall, the North Norfolk Railway and Weybourne Station.

Heydon Hall appeared in *The Grotesque* (1995) with Alan Bates, Anne Massey and Sting, and *The Moonstone* (TV film, 1996). A television crew spent two days at Heydon Hall in spring 2021, filming scenes for *This Sceptered Isle,* a five-part drama about the first wave of the Covid-19 pandemic in the UK. It is scheduled for transmission in autumn 2022 and the cast is reported to include Kenneth Branagh as Boris Johnson, Ophelia Lovibond as Carrie Symonds and Simon Paisley Day as Dominic Cummings. Heydon Hall stands in Heydon Park, which is generally open to walkers, though the hall itself is private.

Heydon Church and village green.

A Cock and Bull Story (2004), which starred Steve Coogan, Rob Brydon, Keeley Hawes and Gillian Anderson, used Heydon, Felbrigg and Blickling Halls. *The Wicked Lady* (1945), starring Margaret Lockwood and James Mason, was filmed at Blickling Hall.

Holkham Hall is another popular film location and appeared in *The Duchess* (2008), starring Keira Knightley and Ralph Fiennes, *Glorious 39* (2009) with Romola Garai, Julie Christie and David Tennant, *The Barbarian Princess* (2009), *Dean Spanley* (2008) and *The Lost Prince* (2003). Along with locations in Cromer, Sheringham, Blickling, Burnham Deepdale and Sandringham, the First World War drama *All the King's Men* (BBC TV, 1999) was also partly filmed at Holkham Hall. The leading actors were Sir David Jason and Dame Maggie Smith. Holkham Beach was memorably used in the film *Shakespeare in Love* (1999), with actress Gwyneth Paltrow walking across the golden sands. The beach also appeared in *Operation Crossbow* (1965) with Sophia Loren, *The Eagle Has Landed* (1976) starring Michael Caine, *Annihilation* (2018), and in the music video for *Pure Shores* by All Saints on a chilly day in January 2000.

Other Locations

The ITV drama series *Kingdom* ran from 2007 to 2009 and was mainly filmed in Swaffham town centre and on the quayside at Wells-next-the-Sea, around 25 miles away. The two locations merged on screen to become the fictional Norfolk town of Market Shipborough. It starred Stephen Fry as solicitor Peter Kingdom and Hermione Norris

Swaffham town centre in 1999.

as Beatrice Kingdom, plus Celia Imrie and Tony Slattery. Featured Swaffham landmarks included Oakleigh House, which doubled as Kingdom's office, and the eighteenth-century buttercross. Market Shipborough's The Startled Duck public house was actually The Greyhound in Swaffham. Numerous other Norfolk locations were used including Dereham, Happisburgh Lighthouse, Holkham, Little Snoring Airfield and Thetford. Some of the cast's attempts at a Norfolk accent were more West Country than East Anglian!

Bintree (also known as Bintry) Watermill on the River Wensum near Guist was used in a television adaptation of George Eliot's novel *The Mill on the Floss*. Filming took place in 1996 and the finished work – starring Emily Watson and Bernard Hill – was first shown on BBC TV on 1 January 1997. The normally white exterior walls were blackened to give the impression of a working mill, and a temporary plastic bridge was installed which disappeared along with the film crew. Some scenes in the film *Tarka the Otter* (1979) were also filmed at Bintree Mill, which stands in picturesque surroundings away from the village of Bintree and is not open to the public.

Another Norfolk watermill was controversially sacrificed during the making of a Hollywood horror film titled *The Shuttered Room*. Hardingham Mill near Wymondham was deliberately burned down on 29 May 1966 for the final scenes of the movie starring

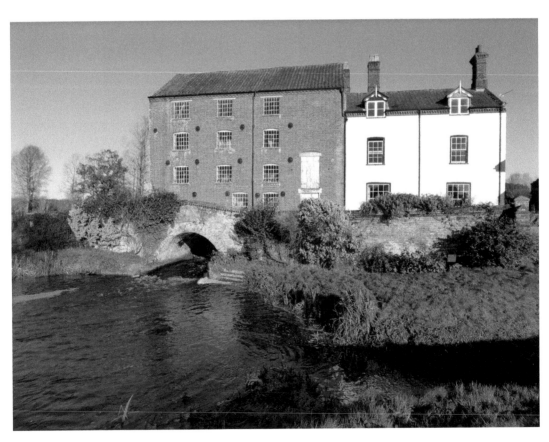

Bintree (aka Bintry) Watermill.

Gig Young, Carol Lynley, Oliver Reed and Dame Flora Robson. It was not considered worthy of listed building status and was already in a dangerous condition when its owner sold it to the film production company for the rumoured but unconfirmed sum of just £50. Despite the belated best efforts of the local MP, conservationists and even comedian Spike Milligan, the burning went ahead as planned.

Several movies have been at least partly filmed in and around King's Lynn. King Street stood in for eighteenth-century New York in *Revolution* (1985) with Al Pacino, Donald Sutherland and Nastassja Kinski. *The Personal Life of David Copperfield* (2020) included scenes supposedly of Great Yarmouth docks that were actually filmed in King's Lynn. The all-star cast included Ben Wishaw, Peter Capaldi, Hugh Laurie and Tilda Swinton. *The Silver Fleet* (1943), starring Ralph Richardson and Googie Withers, and *Operation Crossbow* (1965) with Sophia Loren, were partly made in King's Lynn. *One of Our Aircraft is Missing* (1942) and *The Dam Busters* (1954), starring Richard Todd and Michael Redgrave, used footage of King's Lynn plus the Wash, which in *The Dam Busters* stood in for the Dutch coast. Castle Rising near King's Lynn doubled for Denmark in *Out of Africa* (1985), which starred Robert Redford and Meryl Streep. Walpole St Andrew near King's Lynn deputised for wartime Dunkirk in the film *Atonement* (2007), starring Keira Knightley and James McAvoy.

King Street, King's Lynn. (Photo © Jonathan Thacker, CC-BY-SA/2.0, geograph.org.uk)

6. Norfolk's Music Links

Musicians with Local Connections

Before achieving world domination and becoming the biggest and most influential pop/rock group of all time, The Beatles backed Norwich-born singer Tony Sheridan (1940–2013) in Hamburg, Germany, in 1961/2. He recorded a number of songs with the Liverpool combo and a version of the old standard 'My Bonnie', credited to Tony Sheridan and The Beatles, clocked up one week at number 48 on the British singles chart in June 1963. Sheridan was raised in Thorpe St Andrew on the outskirts of Norwich and was a pupil at the City of Norwich School. Though well remembered in his native Norfolk, his brief period of fame was quickly and completely eclipsed by that of his old backing group. He lived near Hamburg for much of his adult life and died there following heart surgery.

Another Norfolk connection with the 'Fab Four' relates to a song on the band's classic 1967 album *Sgt Pepper's Lonely Hearts Club Band*. Pablo Fanque (real name William Darby), a nineteenth-century Norwich-born circus owner, gets a brief mention in 'Being for the Benefit of Mr Kite'. It was inspired by a poster advertising a show put on by Fanque in 1843. His blue plaque, which references the song, is on the John Lewis building in Norwich.

The Beatles played two sessions at the Grosvenor Rooms in Norwich on 17 May 1963. The venue on Prince of Wales Road is long gone but another blue plaque hangs on an exterior wall of Grosvenor House, an office building that now occupies the site. Their only other live appearances in the county were in Great Yarmouth.

Drummer Roger Taylor, a member of the massively successful band Queen, was born in King's Lynn. As a child he first lived in the town's High Street and then in Beulah Street. He attended Rosebury Avenue School before moving with his family to Truro in Cornwall. Taylor later joined musical forces with singer and pianist Freddie Mercury, guitarist Brian May and bassist John Deacon. The rest, as they say, is history.

Ed Sheeran played many gigs in Norwich during the early part of his meteoric career. He won the 'New Best Thing' contest at the UEA in 2008 and launched the 2009 competition playing outside the Forum in the city centre. Sheeran performed at the 2009 Norwich Fringe Festival and played an unannounced house gig in Dereham Road in January 2010, where he gave the first live rendition of his song 'The A Team'. He returned to the UEA as a headliner in 2011 and has also played at Epic Studios and the Waterfront.

London-born progressive rock keyboard wizard Rick Wakeman has lived near Diss in South Norfolk since 2004. Formerly a member of the bands Yes and The Strawbs,

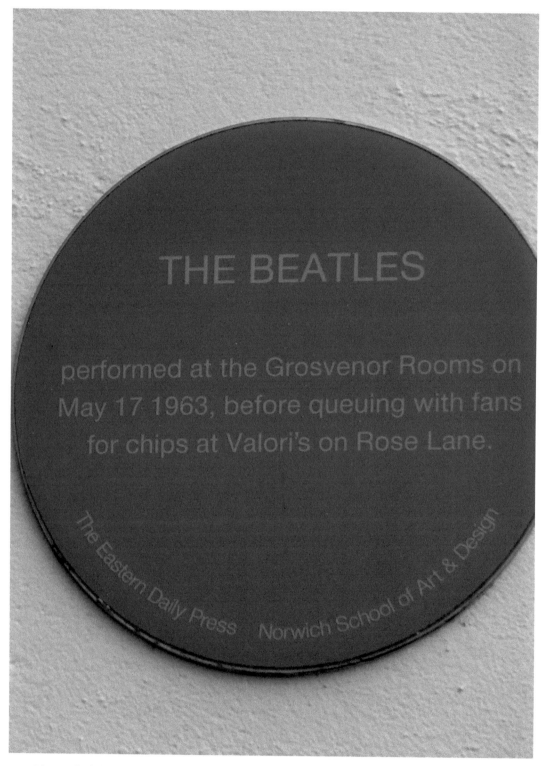

THE BEATLES

performed at the Grosvenor Rooms on May 17 1963, before queuing with fans for chips at Valori's on Rose Lane.

The Eastern Daily Press Norwich School of Art & Design

The Beatles' plaque, Grosvenor House, Norwich.

he has released a string of solo albums and famously played piano on David Bowie's 'Life on Mars' and Cat Stevens' 'Morning Has Broken'. Wakeman has switched on the Christmas lights in Diss and officially opened the town's museum for the 2016 season. He also actively campaigned to save his village post office. Part of an edition of *Celebrity Antiques Road Trip*, with Wakeman competing against his friend Ian Lavender of *Dad's Army* fame, was recorded at Norwich Cathedral on 12 May 2016. Rick got to grips with the mighty pipe organ to 'Wakemanise' an ancient piece of music graffiti. He has played numerous gigs in Norfolk and was made a CBE in 2021 for services to music and broadcasting.

Guitarist Mick Taylor, a member of The Rolling Stones from 1969 to 1974, also lives in the Diss area. His first live appearance with the band was at the legendary Hyde Park concert on 5 July 1969, in memory of the recently departed Brian Jones. The Mick Taylor Band played at the Waterfront venue in Norwich in December 2008.

Singer and songwriter Kathy Dennis was born in Norwich and attended Taverham High School. She later worked for Norwich Union (Aviva) before recording several hit records including 'Touch Me (All Night Long)', a UK number 5 and US number 2 in 1991. Her biggest-selling composition to date is 'Can't Get You out of My Head', a massive worldwide hit for Kylie Minogue. Her songs have also been recorded by Britney Spears, The Spice Girls, Katy Perry, Will Young and others.

Another singer-songwriter, Beth Orton, was born in Dereham but moved to London as a teenager. She broke through to an international audience with her album *Trailer Park* in 1996 and remains a popular artist.

Myleene Klass, a classically trained pianist, presenter and former member of the group Hear'Say, was born in Gorleston near Great Yarmouth. She attended Notre Dame High School in Norwich, Cliff Park Ormiston Academy in Gorleston and the East Coast College's Yarmouth Campus.

Another Gorleston girl, Hannah Spearritt was part of highly successful pop group S Club 7 from 1999 to 2003. They had four British number 1 singles and sold around 14 million albums worldwide. Hannah attended Gorleston's Lynn Grove High School and East Norfolk Sixth Form College. Since 2003 she has forged a career as an actor and has appeared in many television dramas including ITV's *Primeval* and the BBC shows *Casualty*, *Death in Paradise* and *EastEnders*.

Former British Army officer turned singer-songwriter James Blunt lived in Cley Mill as a child when it was owned and run as a guest house by his parents, Colonel Charles and Jane Blount. It had been owned by his grandfather, Lieutenant Colonel Hubert Blount, since 1934. James Blunt's debut album, *Back to Bedlam* (2004), sold over 11 million copies worldwide.

Another best-selling singer-songwriter, David Gray first bought a holiday cottage at Stiffkey and later purchased a home near Hunstanton. Gray, who lists Blakeney and Cromer among his favourite locations, rose to worldwide fame with his album *White Ladder* and songs such as 'Babylon' and 'This Year's Love'.

Other performers who have homes in Norfolk include superstar singer and drummer Phil Collins, who keeps a property in Dersingham near King's Lynn, American-born singer Lene Lovich, who for many years has lived near Downham

The popular waterside village of Blakeney.

Market, and drummer Ash Soan of Del Amitri, who lives and records in Booton near Reepham.

Norwich-based group The Precious Few recorded a version of 'Young Girl' for Pye Records which was released on 29 March 1968. This coincided with the UK release of the original by US band The Union Gap featuring Gary Puckett, which went on to top the charts. The Precious Few's effort never registered nationally but briefly topped a Norwich chart published in the local press. The group broke up soon after but reunited in 2016 for a 'Golden Years' gig at The Talk in Norwich, where they had played half a century earlier when it was the Melody Rooms.

One of the best-known Norfolk groups of the early 1960s, Peter Jay and The Jaywalkers, came together at Norwich City College and had a minor UK hit single in 1962 with 'Can Can 62'. They supported The Beatles on their UK tour in late 1963 but disbanded in 1966 after supporting The Rolling Stones, The Yardbirds and Ike and Tina Turner on a UK tour which included a concert at the Royal Albert Hall. Drummer Peter Jay and his father, Jack, bought the Hippodrome in Great Yarmouth in the 1970s and the Jay family continues to run the venue as a successful circus.

Left: Yarmouth Hippodrome. *Right*: 'Heronby', Wroxham.

George Formby (1904–61), arguably one of Britain's first 'pop' stars and a singer-composer of slightly risqué novelty songs, bought a holiday home on the Broads in the 1940s. The property, named 'Heronby', is located on Beech Road, off The Avenue, in Wroxham and is still privately owned. Formby and his wife/manager, Beryl, spent several summers there and were special guests at the official launch of Herbert Woods' 100-seater Broads cruiser *Her Majesty* in 1950. George Formby played the ukulele and banjolele and his best-known songs include 'When I'm Cleaning Windows' and 'My Little Stick of Blackpool Rock'. He was also a star of many films and was once Britain's highest-paid entertainer.

Allan Smethurst (1927–2000), another singer and writer of novelty songs, was born in Lancashire but his mother came from Stiffkey and the family moved to Sheringham when he was eleven. Known as the 'Singing Postman', Smethurst was a genuine 'postie' and despite not being a 'native', had a strong Norfolk accent that extended to his singing voice. He had a local hit with 'Hev Yew Gotta Loight, Boy?' in 1965, for which he won the Ivor Novello Award for best novelty song the following year. He performed on television and in summer season at the Windmill Theatre in Great Yarmouth, but drink and health problems cut short his career in 1970. He died in a Salvation Army hostel in Grimsby, Lincolnshire.

Artists, Gigs and Venues

It is impossible to list all the acts that played and continue to perform across Norfolk. The venues mentioned here hosted some of the biggest names in pop and rock with particular emphasis on the 1960s–80s.

Norwich

The Orford Cellar, below the old Orford Arms on Red Lion Street in Norwich city centre, hosted many top acts between 1957 and 1974. Legendary band Cream played there twice in 1966 and the Jimi Hendrix Experience followed in January 1967. The Jeff Beck Group, featuring lead vocalist Rod Stewart and future Rolling Stones guitarist Ronnie Wood, arrived a few months later. Other artists who played at the hot and crowded venue include a young David Bowie and Reg Dwight, alias Elton John.

Many major music stars have performed at Norwich Theatre Royal, including David Bowie, Deep Purple, The Kinks, Gene Pitney, Glen Campbell, Oscar Petersen, Art Garfunkel, 10cc, Gene Vincent and the Dave Clark Five. Bowie, who famously referenced the Norfolk Broads in his classic song 'Life on Mars', performed two shows there as his alter ego Ziggy Stardust on 21 May 1973. Some of his fans were dressed in home-made replicas of their hero's outrageous stage outfits, complete with face paint and glitter. Deep Purple, then listed in the Guinness Book of Records as officially the loudest band in the world, rocked the Theatre Royal on 10 and 11 May 1974.

The historic St Andrew's Hall in St George's Street has also hosted a myriad of famous artists ranging from classical orchestras to heavy metal bands. Opera singer Jenny Lind (1820–87), billed as the 'Swedish Nightingale', sang there in 1847 and 1849. Money raised from the concerts helped build the original Jenny Lind Children's Hospital in Pottergate, Norwich, which opened in 1854. Other, very different acts who later appeared there include AC/DC, Iron Maiden, Hawkwind, The Pretenders, The Undertones, Human League, Thin Lizzy, Status Quo, Jethro Tull and many more.

The Melody Rooms in Oak Street (later renamed The Talk) attracted a dazzling array of rock talent including The Who (1965), Cream ('68), Procol Harum ('68), Pink Floyd ('68), Fleetwood Mac ('69), The Kinks ('69), Slade ('71), Status Quo ('72), Wizzard ('73) and ELO ('73). Even the iconic American superstar Roy Orbison performed there during a temporary lull in his career in 1972. It was announced in January 2022 that the venue, which was first opened as the Industrial Club in December 1954, would finally close its doors two months later.

The Gaumont Cinema in All Saints Green, Norwich, welcomed a promising young band named The Rolling Stones on 25 April 1964. Other acts that played there include Gene Vincent, Manfred Mann, Johnny Kid and The Pirates, and The Crystals. The venue became a bingo hall in 1973 and was demolished in 2014.

The Waterfront in King Street has played host to Amy Winehouse, Paul Weller, The Darkness, Nirvana, The Verve, The Arctic Monkeys, The Stereophonics, Pulp, Radiohead, Ellie Goulding, Ed Sheeran and many others since opening its doors in 1993.

Many bands played at the Orford Cellar, Norwich.

Norwich Theatre Royal.

The historic St Andrew's Hall, Norwich.

Great Yarmouth and Gorleston

Great Yarmouth can claim a connection with one of the biggest-selling records of the 1960s. The Tornados, a group that recorded for legendary producer Joe Meek, spent the 1962 summer season backing popular singer Billy Fury at the Windmill Theatre on the 'Golden Mile'. Meanwhile, Meek was at his home in Holloway Road, North London, watching television coverage of the launch of 'Telstar', the world's first communications satellite. The story goes that a melody suddenly came to him that night which would form the basis of the blockbuster instrumental of the same name. He contacted the band, who drove to London after playing a show with Fury in Great Yarmouth. They then spent hours recording 'Telstar' and its B-side 'Jungle Fever' at Meek's home studio, but the tracks were both unfinished when they had to rush back to the Norfolk coast for their next performance.

In their absence, Geoff Goddard, a talented pianist and friend of Meek, overdubbed the melody line of 'Telstar' using a temperamental early electronic keyboard called a Clavioline. Meek added weird sound effects at the beginning and end to help create a futuristic 'space-age' sound unlike anything previously heard on a pop record. The finished disc was released on 17 August 1962 and topped the charts on both sides of the Atlantic, making The Tornados the first British band to achieve an American number 1 hit.

At the end of their summer season in Great Yarmouth, The Tornados were suddenly propelled to temporary stardom but had to fulfil a contract as Billy Fury's backing musicians on a forty-nine-date tour of the UK. It is said that they were unimpressed with the strange sound of 'Telstar' and had to buy a copy to learn how to play it live during a three-minute 'solo' slot each night. The Windmill Theatre is now an indoor golf venue.

The Beatles performed four shows at the old ABC Cinema in Regent Street, Great Yarmouth, on 30 June and 28 July 1963. Ticket prices ranged from four shillings and sixpence (22½ pence) to nine shillings and sixpence (47½ pence)! Amazingly, a programme for one of the shows was advertised for sale online in 2021 with an asking price of £500. Other acts that appeared there during the 1960s include Cliff Richard and The Shadows, Tom Jones, The Kinks, The Moody Blues, Them (featuring Van Morrison), The Walker Brothers and Marianne Faithfull. The ABC was torn down in 1989 and the Market Gates shopping centre now stands on the site.

The Britannia Pier Theatre on the seafront hosted many artists including a virtually unknown David Bowie with his group The Buzz, and Cilla Black. The Who played in the town at least six times during 1965–66 at the Britannia Pier Theatre and the Tower Ballroom. The Move (featuring Roy Wood) appeared at the Aquarium several times in June and July 1967.

The original line-up of Pink Floyd, with Sid Barrett on guitar and vocals, played at the Floral Hall in Gorleston on 19 July 1967. The band's hit single 'See Emily Play' was in the charts at the time and the small venue was packed with around 800 people. A BBC film crew apparently recorded the show but it is unclear whether the footage was used. The venue still exists as the Ocean Room on Gorleston seafront near the Pier Hotel.

The former Windmill Theatre, Great Yarmouth.

Left: Britannia Pier Theatre, Great Yarmouth. *Right*: Ocean Room, Gorleston.

Numerous other acts have passed through its doors over the years including Blur in 1995 and Rag'n'Bone Man, who made a surprise appearance in 2020.

North Norfolk

A small North Norfolk venue hosted an amazing number of big-name acts during the 1970s and early 1980s. West Runton Pavilion near Cromer attracted the likes of Chuck Berry, Black Sabbath, The Clash, The Damned, The Jam, Joy Division, Motorhead, Iggy Pop, The Sex Pistols, Slade, T. Rex and many more. The Pavilion was demolished in 1986 but a blue plaque in its memory is on the wall of the Village Inn at West Runton.

Not to be confused with the above, the Royal Links Pavilion on Overstrand Road, Cromer, also hosted star bands including The Who (1967), The Move (1969), Slade (1972), Status Quo (1972), Queen (1974), Thin Lizzy (several dates 1971–76) and The Sweet (1968 and 1971). The Sex Pistols played the penultimate date of their last UK tour at the Royal Links Pavilion on Christmas Eve 1977. It mysteriously burned down on 5 April 1978.

Blue plaque at West Runton. (Stavros1)